THEN & NOW

MYRTLE BEACH
AND THE GRAND STRAND

THEN & NOW

MYRTLE BEACH
AND THE GRAND STRAND

Susan Hoffer McMillan

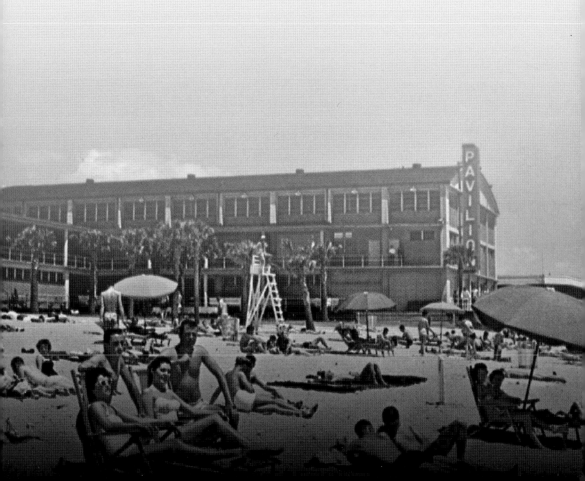

To Katherine Durning, Carol Gomolski, Louise Krechel, Joanne Milnor, Tim Schoen, Sandy Sheedy, Steve Sheedy, and Hal Vivian, in appreciation for your continuing work in archaeology.

Copyright © 2007 by Susan Hoffer McMillan
ISBN 978-0-7385-5270-5

Library of Congress control number: 2007923778

Published by Arcadia Publishing
Charleston, South Carolina

Printed in the United States of America

Then and Now is a registered trademark and is used under license from Salamander Books Limited

For all general information contact Arcadia Publishing at:
Telephone 843-853-2070
Fax 843-853-0044
E-mail sales@arcadiapublishing.com
For customer service and orders:
Toll-Free 1-888-313-2665

Visit us on the Internet at www.arcadiapublishing.com

ON THE FRONT COVER: The Myrtle Beach Pavilion (1949–2006) was a local icon for 57 years. The city literally grew up around this pavilion and its nearby predecessors. The concrete, block, and steel pavilion entertained guests with arcade games and food concessions on the ground floor, and live bands and special events—ranging from beauty pageants to wrestling—in an upstairs dance hall named the Magic Attic. Temporarily vacant property where the pavilion and adjoining amusement park operated will be redeveloped in 2008 by owner Burroughs and Chapin Company. (This photograph and images throughout the book are courtesy of the author unless otherwise noted.)

ON THE BACK COVER: Beach vacations are memorable, especially with pictures to help recall and share the experience. A 1940s view depicts 7 young women who were among 18 guests vacationing in the house shown behind them on the right. Unfortunately the women are unidentified, but their shared pleasure in vacationing in Myrtle Beach is clearly seen in this view and in a companion photograph taken on the porch. House parties remain an ideal way to reconnect with friends and family.

CONTENTS

ACKNOWLEDGMENTS

This is the fourth book in a series chronicling yesteryear images of the Grand Strand, including Myrtle Beach, North Myrtle Beach, Little River, Surfside Beach, Garden City Beach, Murrells Inlet, Litchfield Beach, Pawleys Island, and Georgetown. Feedback from earlier volumes—*Myrtle Beach and Conway in Vintage Postcards*, *Georgetown and the Waccamaw Neck in Vintage Postcards*, and Images of America: *Myrtle Beach and the Grand Strand*—came from many readers who collectively contributed significantly to this volume. Thanks are extended to all who offered information expanding this view of the past. Great care was taken to interpret facts accurately. Additional historical data was extracted from the Horry County Historical Society's publication, *The Independent Republic Quarterly*; from the Myrtle Beach *Sun News* newspaper; and from *Populuxe Motels: Preservation in Myrtle Beach, South Carolina and the Wildwoods, New Jersey* by Katherine J. Fuller. Other information and technical assistance was provided by North Myrtle Beach historian C. Burgin Berry, Harold Clardy, Robert Dinkins of Myrtle Beach State Park, Shane Duffy of Executive Helicopters, Barry Garren, Elizabeth Johnson at South Carolina Archives and History Center, Martha Ann Johnson, Franklin Long of Burroughs and Chapin Company, Buddy Owens of Cherry Grove Sales, Inc., Tim Ribar, Dr. Frank Sanders, Ray Tinnsman of Carolina Cooling, and the capable staff of Myrtle Beach Photo Plus. This book builds upon my previous pictorial histories of the Grand Strand and is not intended as a comprehensive volume on its subject. Vintage images are from my collection with two noted exceptions; photographing current images was a splendid adventure. Much appreciation is extended to publisher Lauren Bobier at Arcadia Publishing for her guidance and encouragement, to Dr. Roy Talbert of Coastal Carolina University for editing the manuscript, and to my husband, Marshall, children, and friends for indulging yet another hysterically paced, historical project.

INTRODUCTION

Myrtle Beach and the Grand Strand form a coastal crescent first named Long Bay. The area is now recognized globally for its breadth of recreation, dining, accommodations, entertainment, and shopping. Incorporated in 1938, Myrtle Beach became a city in 1957 and has 25,000 residents. The Grand Strand's population is 216,000. Approximately 14 million annual visitors enjoy Strand hospitality, including its 60 miles of beaches, 90,000 rooms, 1,800 restaurants, 100 golf courses, 8 major shopping areas, 8 live entertainment theaters, 8 fishing piers, 2 state parks, an aquarium, a winery, a zoo, and multiple campgrounds, marinas, and other attractions. Cultural opportunities provided by Brookgreen Gardens, Chapin Library, Children's Museum of South Carolina, Coastal Carolina University, Franklin G. Burroughs and Simeon B. Chapin Art Museum, Long Bay Symphony, Waccamaw Arts and Crafts Guild, and other venues strengthen area appeal. Strong medical, financial, and legal support services are vital amenities also represented.

Tourism peaks on July 4, a tradition beginning when Carolina cotton mills closed for the annual holiday and mill employees vacationed at the beach. An annual Sun Fun Festival launched in 1951 by Myrtle Beach Area Chamber of Commerce continues to encourage early-summer vacationers. Added festivals now occur all year long. The chamber increased marketing following Hurricane Hazel in 1954 to reassure tourists that hotels could accommodate guests, and its pace never slowed down. Canadians, golfers, and snowbirds (extended-stay winter tourists) are targeted by promotions, increasing tourism in non-traditional months. For example, Canadian-American Days encourages Canadians to escape winter and enjoy the Strand's early spring temperatures. Golfers have a tremendous local impact, thanks to the early organizing efforts of Golf Holiday, which first packaged golf and hotel discounts. A semiannual Society of Stranders (S.O.S.) Reunion draws thousands of beach music fans to North Myrtle Beach to relive their youth by shag dancing to 1950s and 1960s tunes. Lacking a deepwater harbor until the Intracoastal Waterway opened in 1936, Myrtle Beach tourism historically relied upon automobile traffic. Myrtle Beach International Airport grew out of Myrtle Beach Air Force Base facilities and is a major tourism contributor. The Carolina Opry opened in 1986 as the first sizeable, live, commercial entertainment theater, with others soon following to expand Myrtle Beach's appeal as a motor coach destination. Waccamaw Pottery blossomed on Highway 501, and outlet malls appeared, encouraging busloads of bargain-seeking shoppers. A $400 million Hard Rock Theme Park slated to open in 2008 near Highway 501 on the waterway will be the area's largest single commercial project to date.

The Strand's hotels, restaurants, retail stores, and residential housing have improved in overall quality in recent decades, impacting tourism and population demographics by shifting Myrtle Beach's image from a predominantly working-class, blue-collar beach to a diversified one with an increasingly upscale component particularly attractive to retirees, whose presence is felt throughout the Strand. As long as the sun continues to shine over Myrtle Beach and the Grand Strand, its leadership will be challenged to maintain natural resources while accommodating dynamic growth.

MYRTLE BEACH

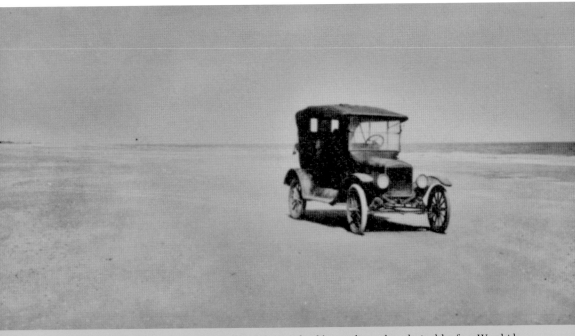

Myrtle Beach's wide strand was its hallmark long before this Model T Ford was photographed on the beach in 1928. This view was taken from a series on Myrtle Beach's natural beauty photographed for publication in *Arcady*, a 1929 real estate promotional book published in New York. The book's grandiose plan, devised by four Woodside brothers from Greenville who had bought a large tract in Myrtle Beach, was doomed by the New York Stock Exchange crash that October. World War II ended before Myrtle Beach development rebounded to its 1920s pace.

Withers Swash, approximately Fourth Avenue South, was a popular estuary for harvesting shellfish and flounder when its pristine shores were photographed in the late 1930s. The name derives from a distinguished family who acquired surrounding land in the late 1700s and maintained an antebellum indigo plantation here. Spivey's Swash was an early-20th-century name for this drainage system. A recent aerial view shows the swash flowing through Family Kingdom Amusement Park to access the ocean. Withers Park on Withers Swash Drive offers a pier view of an undeveloped swash area.

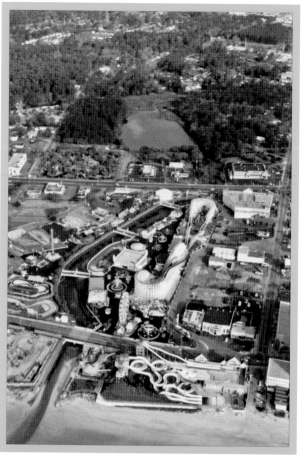

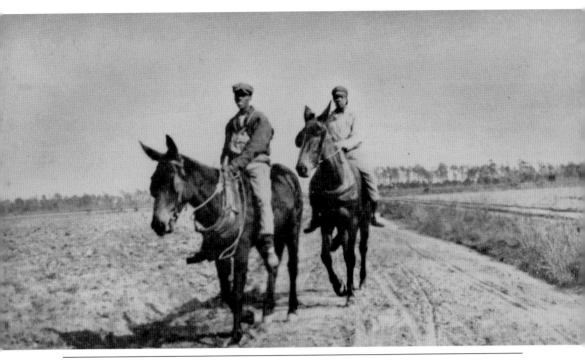

Several African American employees of Myrtle Beach Farms Company, established in 1912, are depicted riding company mules through its 500-acre truck farm in 1928. The company's land holdings included most of Myrtle Beach, resulting in their transition from farming to real estate development and sales. Reorganized as Burroughs and Chapin Company, it owns and operates Broadway at the Beach, a 350-acre shopping, dining, and entertainment complex overlapping its former corn and potato fields. Broadway is shown aerially here, with the pyramidal Hard Rock Cafe near the center.

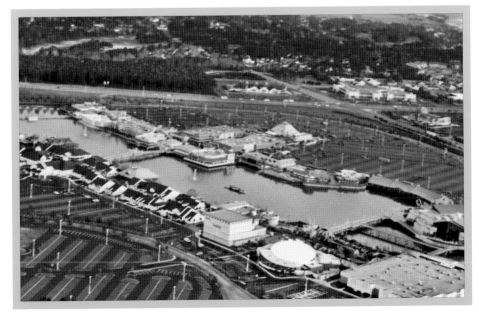

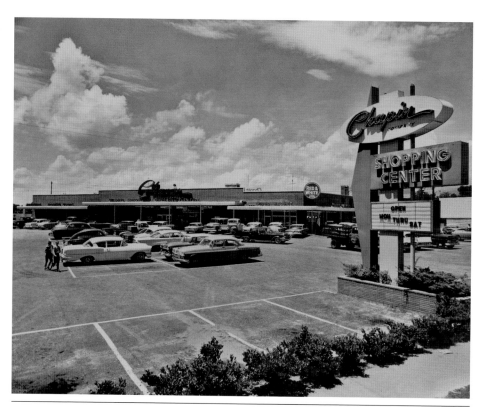

Chapin Company was the department store occupying a city block fronting the south side of Main Street from 1928 until it was phased out in 2000. It was named for founder Simeon B. Chapin. Only the company office remains in this location, overseeing its leased properties. The thatched huts of Mount Atlanticus Miniature Golf appear as mushrooms sprouting from the roof of this former retail business that now predominantly houses a multitiered miniature golf course. (Then photograph courtesy of Chapin Company.)

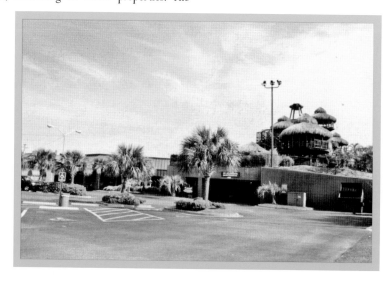

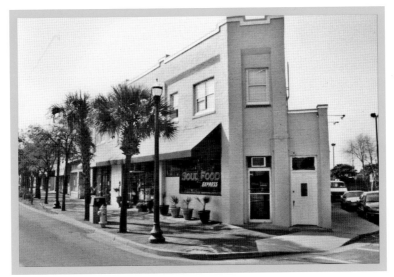

Kozy Korner Restaurant and Grill, 819 Main Street, occupied one of Myrtle Beach's oldest downtown properties, dating to the late 1920s. Shown about 1947 and again recently, this triangular building has the unusual distinction of a basement that was once the restaurant's bar. The building's main floor now houses the Soul Food Express restaurant, easily distinguished by its turquoise exterior.

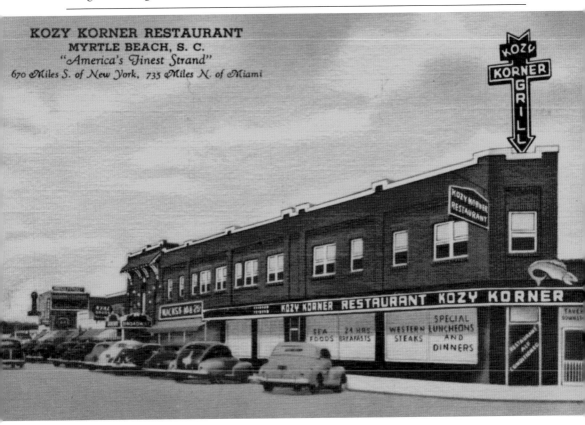

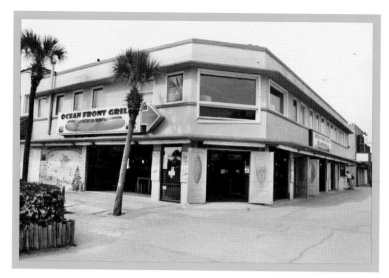

The Hobeika Building, 100 Ninth Avenue North, was named for the family who owned and operated its Ocean Front Grill. Shown in 1954, the building earlier housed Ye Olde Tavern and bathhouses. The tavern offered a buffet lunch, and a patio extended over the dunes and beach for outdoor dining and dancing. The grill still operates in this same location beside the former Myrtle Beach Pavilion.

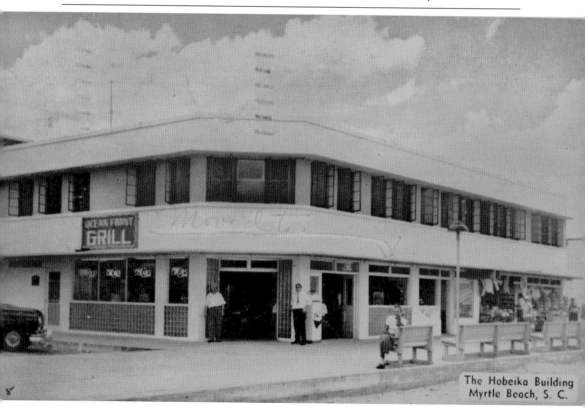

The Hobeika Building
Myrtle Beach, S. C.

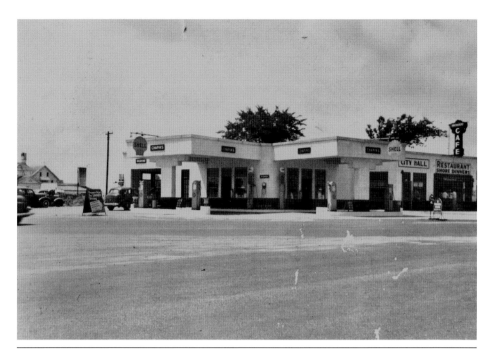

Chapin Company's second Shell gas station was on Kings Highway at Ninth Avenue North on land later incorporated into Myrtle Beach Pavilion Amusement Park. Note the temporary city hall and café restaurant adjoining the gas station in this 1938 view. City hall soon moved next door to the Colonial Building, built that same year. This site was most recently part of the Myrtle Beach Pavilion Amusement Park and is pictured during the demolition of artificial mountains that were part of a hydro surge ride.

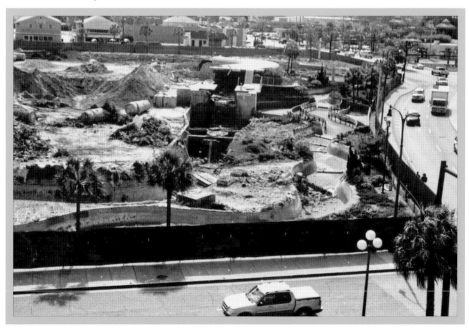

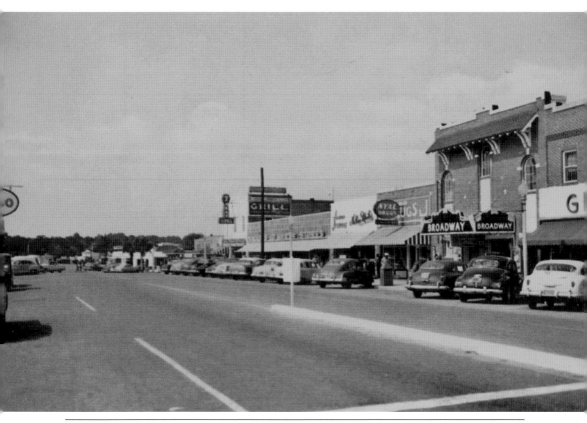

Main Street looking west around 1950 housed the following businesses, from left to right: Seven Seas Restaurant, Mack's 5-10-25 Cents Store, Cut Rate Drugs, Ben's Broadway Theatre, and the Glamour Shop. This street was originally named East Broadway and intersected with Broadway, the early road into Myrtle Beach from Conway via Socastee, prior to the opening of Highway 501 in 1949.

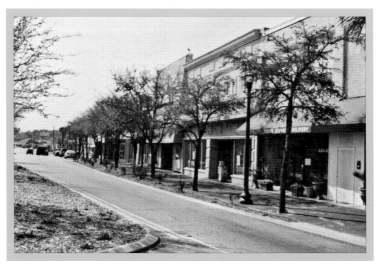

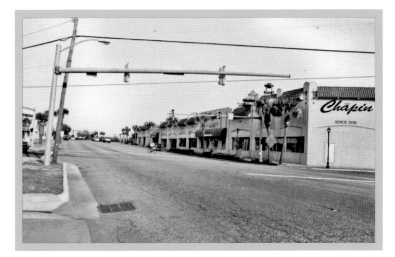

Main Street looking east around 1960 included the following businesses, from left to right: Chapin's Shell Station, Sherrill's Pharmacy, Boyd's Sports Wear, Seven Seas Restaurant, and Nye's Drugs, all opposite the downtown department store Chapin Company. No longer a department store, the Chapin building houses Mount Atlanticus Miniature Golf, an indoor-outdoor course superimposed on this former landmark.

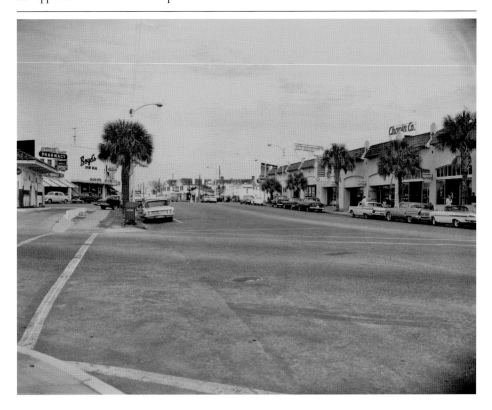

Myrtle Beach Pavilion Amusement Park, 812 North Ocean Boulevard, contained 11 acres bounded by Eighth Avenue North, North Kings Highway, Ninth Avenue North, and the beach. It ceased operation in 2006. Aerial views looking north contrast the park in 1961 with its vacant lot in 2007. The park's German band organ and Hershell-Spillman carousel are both National Register of Historic Places properties relocating to a new Pavilion Nostalgia Park within Broadway at the beach. Redevelopment of this key downtown parcel is anticipated in 2008.

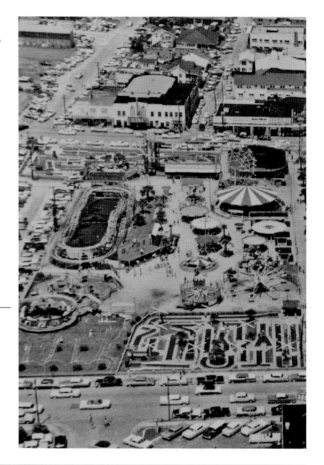

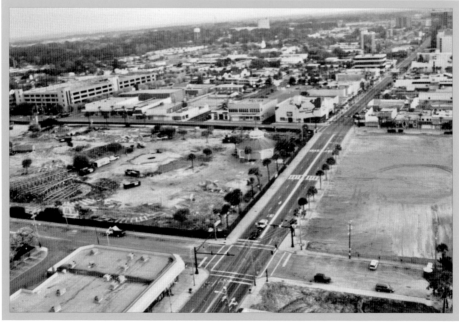

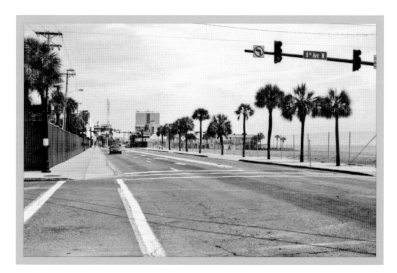

"Cruising" North Ocean Boulevard in the vicinity of the Myrtle Beach Pavilion Amusement Park was a summer ritual for generations of local and out-of-town youths. Guys and gals piled into vehicles with windows open and radios blaring to draw attention. Flirtatious glances, conversations, names, phone numbers, and even passengers were exchanged as the energy-charged vehicle parade passed the pavilion repeatedly whenever the park was open, particularly at night.

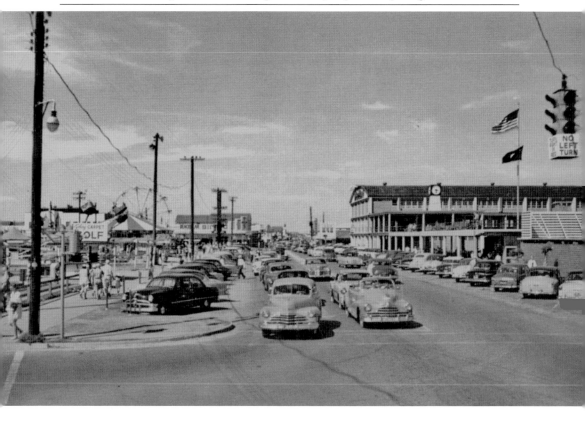

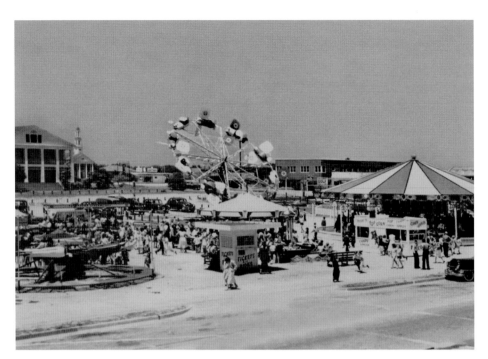

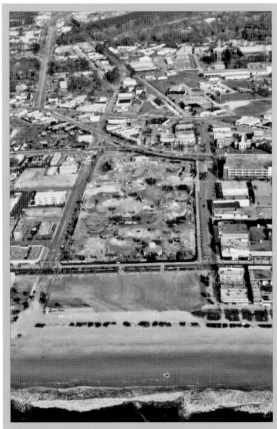

The busy Myrtle Beach Pavilion
Amusement Park in 1950 is contrasted
with its vacant appearance in 2007.
A $6 million Hurricane roller
coaster installed in 2000 was the
largest of its many rides. The wood-
and-steel coaster was 3,800 feet
long and 101 feet high and reached
a speed of 55 miles per hour.

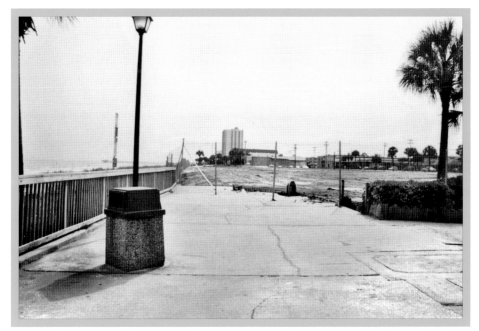

An oceanfront wooden boardwalk was first built in Myrtle Beach in 1908 and spanned eight miles before sections of it were removed. The boardwalk adjoining the Myrtle Beach Pavilion was popular from its beginning. Later rebuilt in concrete, the boardwalk improved access to the beach and to nearby businesses. Replacement of Myrtle Beach's boardwalk at a cost of $10 million is part of a downtown redevelopment plan.

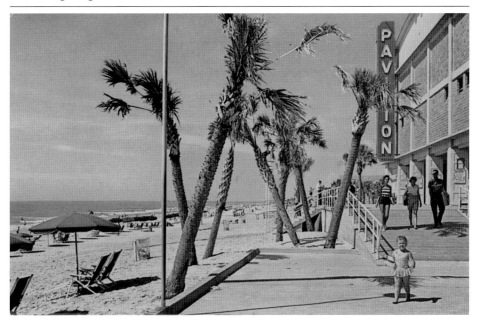

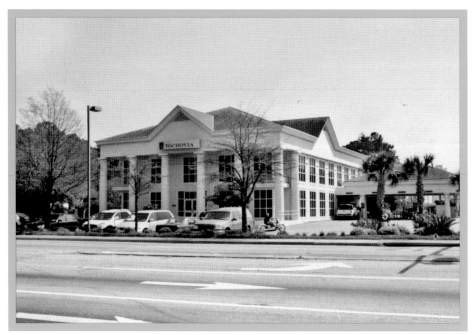

Washington Park Race Track, a harness racing course at 2110 Oak Street, was a major attraction from 1938 until its closing in 1947. A portion of its clay track remains undeveloped and is visible behind Wachovia Bank, built on the corner parcel of the racetrack's larger site. Birds perching on the track's perimeter fence left droppings from which a hedge of shrubs and trees grew, outlining the oval track's surviving section.

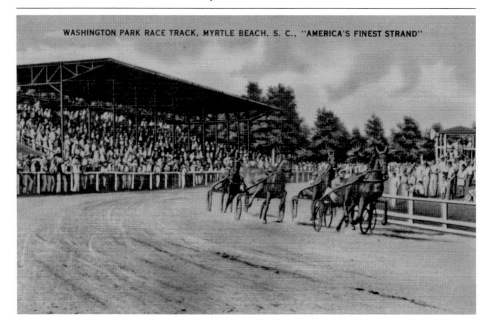

WASHINGTON PARK RACE TRACK, MYRTLE BEACH, S. C., "AMERICA'S FINEST STRAND"

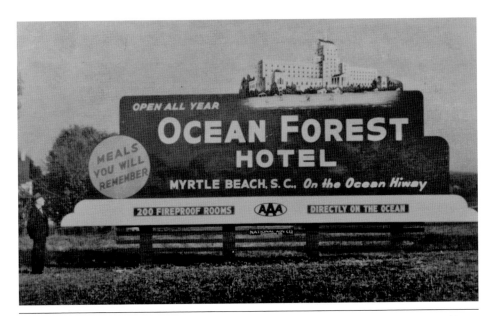

Billboards have marketed Myrtle Beach to vacationers since the 1930s. A 1947 sign promoted the famous Ocean Forest Hotel, which closed in 1974. Ordinances now regulate the size, location, and frequency of signage, but one might not want to challenge this 2007 billboard with a man-eating shark displaying rows of huge, triangular teeth protruding from it. The sign on Highway 17 Bypass at the Twenty-ninth Avenue North Extension promotes Ripley's Aquarium at Broadway at the Beach.

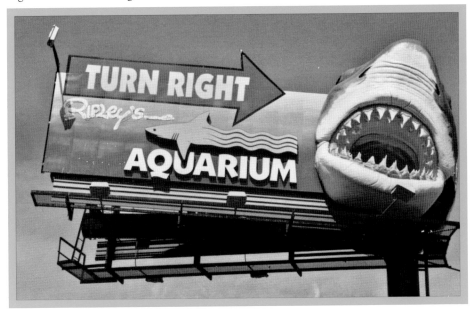

The three "R"s were taught at Myrtle Beach Grade School, 505 North Kings Highway, from 1928 until it burned in 1946 and was replaced with an updated school. The second Myrtle Beach Grade School was demolished in the early 1970s to build the present Myrtle Beach Post Office. Young live oaks on the early school campus are now stately trees surrounding the post office.

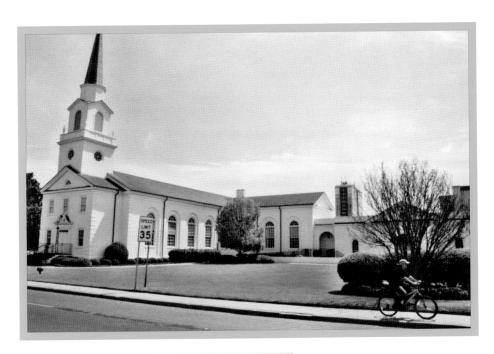

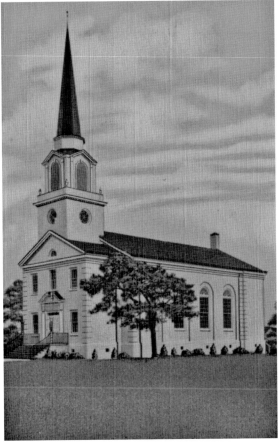

First Presbyterian Church, 1300 North Kings Highway, is seen new in 1948 and recently with several additions. Presbyterians began meeting locally in 1928 and soon built a chapel at 1010 North Kings Highway. This church is relocating to a new 18-acre campus on Robert Grissom Parkway above Thirty-eighth Avenue North. Many faith denominations are represented by several hundred churches in the Grand Strand area.

The Ocean Forest Golf Course opened in 1927 on 300 acres and is the "granddaddy" of Grand Strand golf, which now encompasses over 100 courses. Renamed Pine Lakes International Country Club, it is temporarily closed for reconfiguration. The course retains its original Colonial-style clubhouse at 5603 Woodside Avenue and some original golf holes. The Dunes Golf and Beach Club, 9000 North Ocean Boulevard, was the Grand Strand's second golf course, and it opened in 1949.

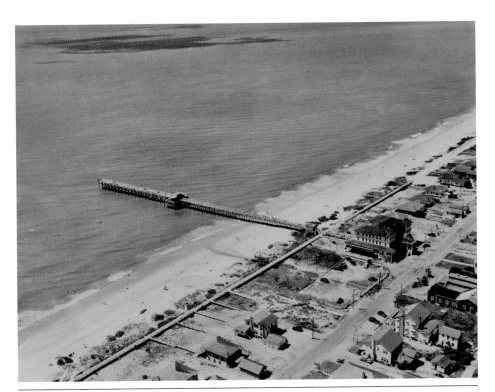

Myrtle Beach Yacht Club opened with 40 rooms and the town's first fishing pier in 1922. Aerial views show the pier and hotel, later renamed the Ocean Plaza Hotel, when they dominated a sparsely developed neighborhood. In a 2007 view, the 1400 North Ocean Boulevard property is distinguishable by its fishing pier, Pier 14, which adjoins the Yachtsman Resort, a condominium hotel that was the tallest building in Myrtle Beach when constructed in the early 1970s.

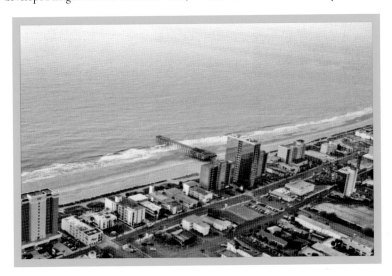

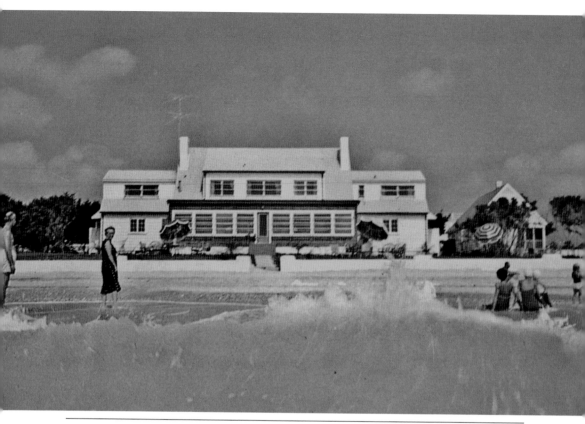

The Sea Captain's House, 3002 North Ocean Boulevard, is a restaurant built in 1930 as a beach house for the Henry Taylor family of High Point, North Carolina. Nellie G. Howard acquired it in 1954 and operated it as a guesthouse named Howard Manor. A north wing addition and an enclosed patio enlarged the *c.* 1962 nautical-themed eatery in recent years. It belongs to the Clay Brittain family, who is redeveloping the adjoining Carribean Resort and Villas.

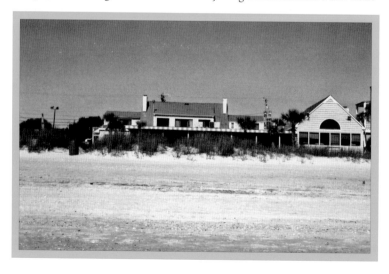

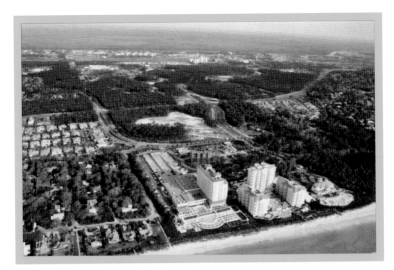

Grande Dunes is the upscale development of Myrtle Beach's last remaining land tract, spanning from the Atlantic Ocean to west of the Intracoastal Waterway, by owner Burroughs and Chapin Company. Pictured in 1996 and in 2007, the 2,200 acres exhibit an oceanfront Marriott Resort, single- and multi-family housing, professional offices, and commercial development. It includes Grande Dunes Marina on the waterway with adjoining accommodations and retail stores. (Then photograph courtesy of Tim Ribar and Burroughs and Chapin Company.)

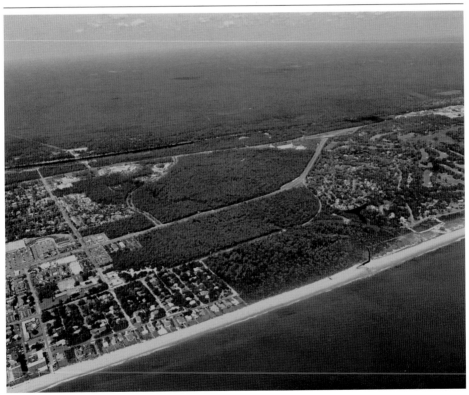

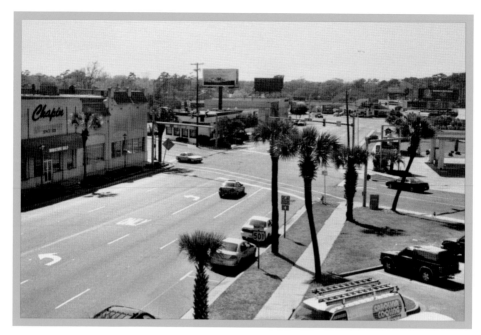

A 1940s rooftop view of the intersection of Main and Oak Streets reveals its appearance before Chapin Company expanded to this corner. Chapin's opened in 1928 and housed the post office, a drugstore, a grocery store, and specialty departments selling almost everything needed for living or vacationing at the beach. The 2007 view of this intersection was taken from the roof of Gene Ho Photography's building.

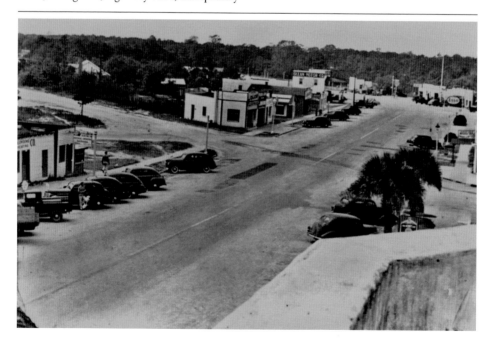

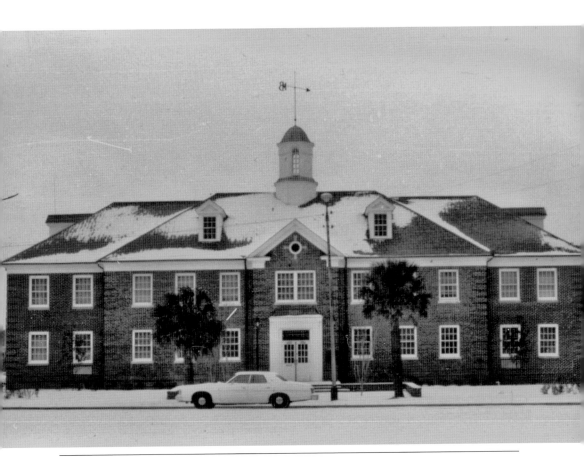

Myrtle Beach City Hall, 937 Broadway Street, was built *c.* 1949 and later expanded with twin extensions on both ends of its Georgian brick structure. Photographed after a rare snowfall about 1960 and again in 2007, the city's administration building was designed by the first local architect, James E. Cooney. Additional city offices are housed in nearby facilities.

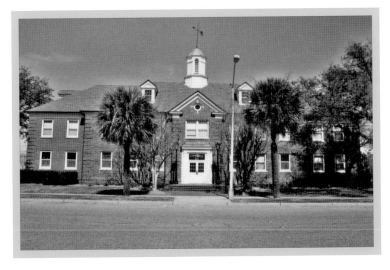

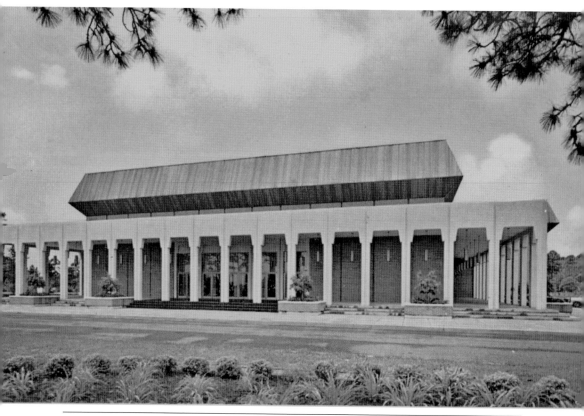

Myrtle Beach Convention Center, 2101 North Oak Street, opened in 1970. After several expansions, it is adjoined by the Sheraton Myrtle Beach Convention Center Hotel, a four-diamond hotel with more than 400 rooms. Both properties are owned by the City of Myrtle Beach. The convention center houses the official South Carolina Hall of Fame with biographical exhibits honoring over 75 distinguished living and deceased South Carolinians.

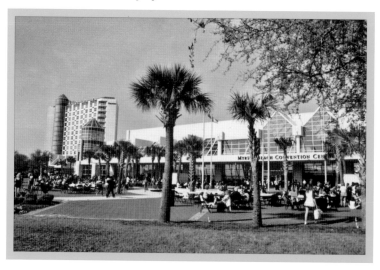

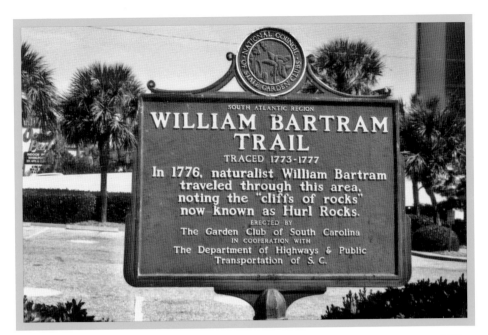

Hurl Rocks are no longer visible at the oceanfront park named for natural rock outcroppings formerly dominating the shore at Twentieth Avenue South. The name also derives from a pioneer local family named Hearl. The rocks were eroded by hurricanes and buried by beach renourishment. A large gazebo and a historical marker commemorating William Bartram's 1776 visit complement the park but hardly compensate for its missing focal point. In past centuries, these rocks were a navigational landmark for sailing ships.

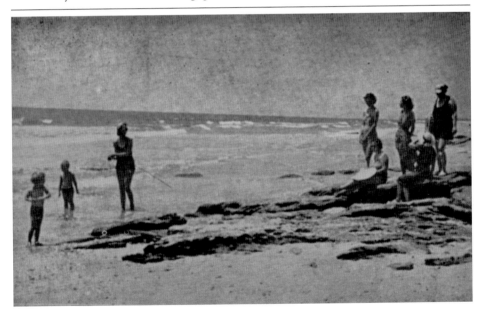

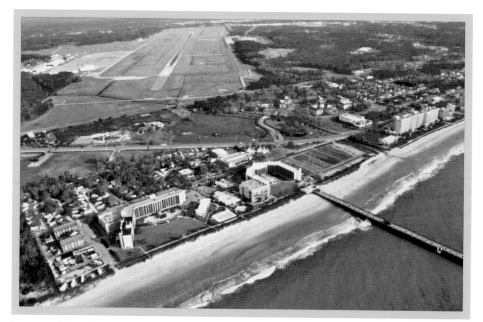

Springmaid Beach Resort, 3200 South Ocean Boulevard, is shown aerially in the 1960s and in 2007, with Myrtle Beach International Airport's runway in the background of the recent view. Springmaid began as an affordable vacation site provided to employees by Springs Mills, based in Fort Mill. It is now a popular convention resort with camping also available. Behind the horseshoe-shaped hotel facing the pier is the Franklin G. Burroughs and Simeon B. Chapin Art Museum at 3100 South Ocean Boulevard. A historic former beach house, the museum appears tiny but has a large place in the area's cultural scene.

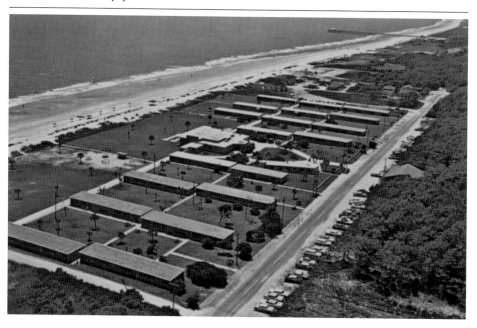

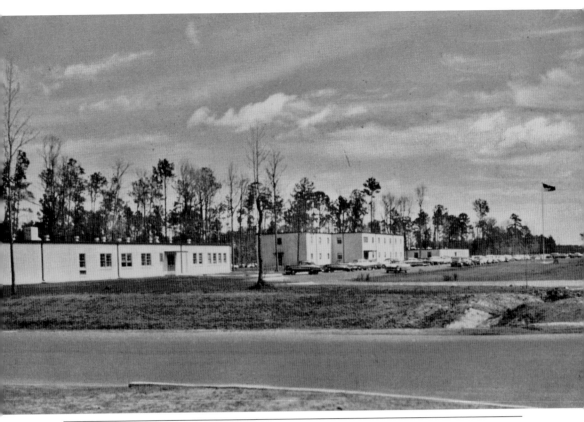

The communications building at Myrtle Beach Air Force Base is shown about 1960. The 3,950-acre base opened in 1942, closed in 1993, and is being redeveloped as a planned urban community of housing, shopping, dining, schools, churches, and parks. New roads and infrastructure support the redevelopment, which has as its centerpiece the Market Common, a 100-acre, high-end commercial and residential project under construction. The base redevelopment is projected to have a total cost of about $1 billion!

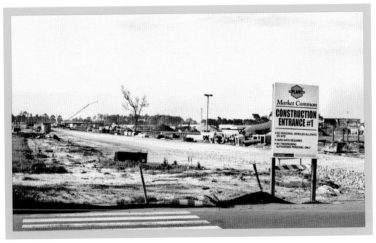

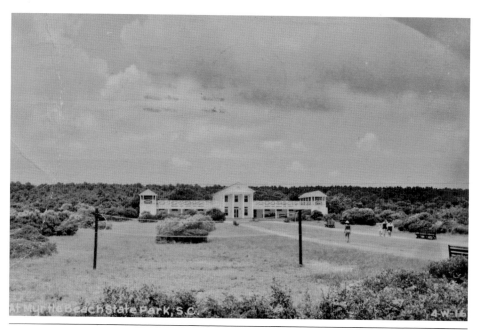

Myrtle Beach State Park, 4401 South Kings Highway, consists of 312 recreational acres with a fishing pier and nearly a mile of beach frontage. It opened as South Carolina's first state park in 1935 with a stately wooden pavilion built by the Civilian Conservation Corps. The pavilion succumbed to Hurricane Hazel in 1954, but the park's campground, cabins, and picnic facilities continue to offer an economic, nature-based vacation alternative. The pavilion and a swimming pool were formerly located on the lawn in the center of this 2007 view.

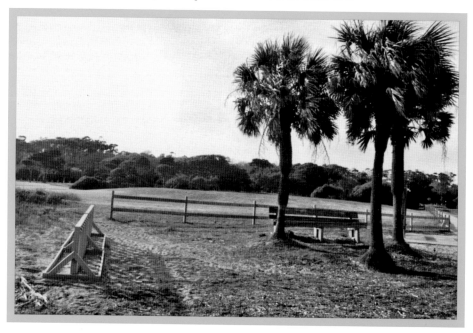

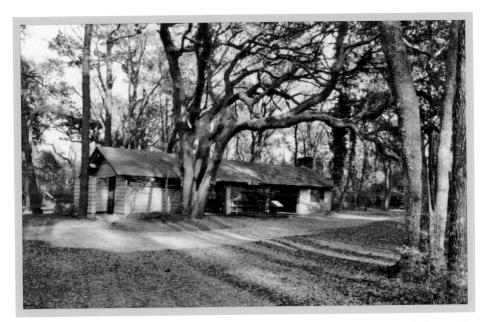

The picnic area at Myrtle Beach State Park is seen around 1949 and in 2007. It has been hosting picnics for over three-quarters of a century; that's a lot of sandwiches, fried chicken, potato chips, soft drinks, and cookies! Located three miles south of Myrtle Beach's downtown, the park offers nature trails for exploring its rare, maritime forest, a National Heritage Site.

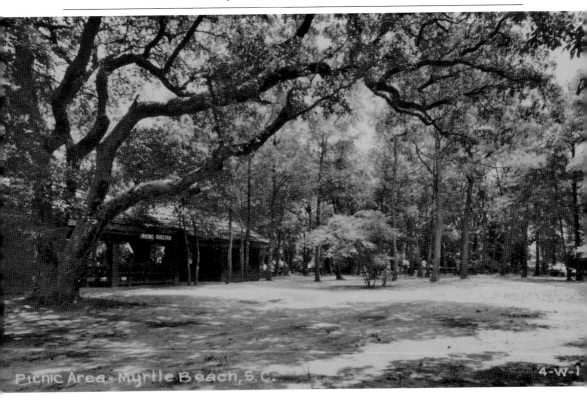

Picnic Area - Myrtle Beach, S.C. 4-W-1

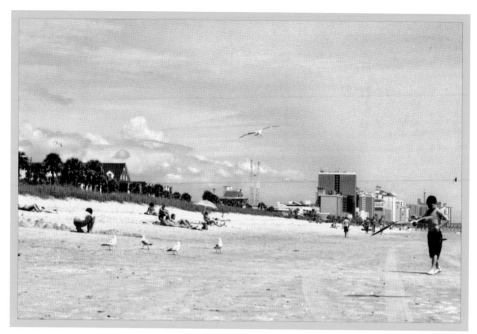

Myrtle Beach's oceanfront, looking north, is shown from around 500 North Ocean Boulevard in 1949 and in a recent view taken from the same location. Maintaining wide, attractive beaches is a challenge for Grand Strand municipalities, involving costly, periodic beach renourishment. Through it all, the beach remains the area's top attraction and best bargain, too.

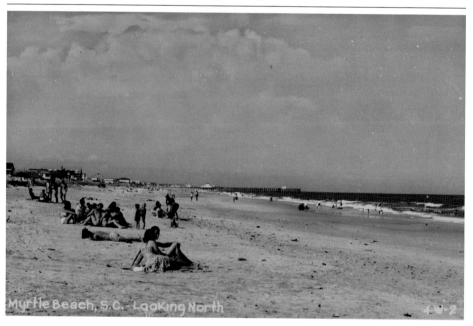

Myrtle Beach, S.C. - Looking North

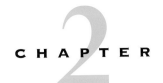

BEACH
ACCOMMODATIONS

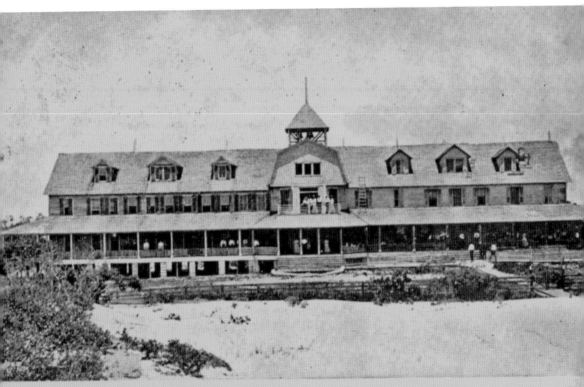

MYRTLE BEACH HOTEL, MYRTLE BEACH, S. C., HORRY CO. Pub. by W. K. Hamilton, Conway, S. C.

When the Seaside Inn was the only local hotel, it was also known as the Myrtle Beach Hotel. Built in 1901 near the intersection of Eighth Avenue North and North Kings Highway, it opened the beach to tourism. Relocated closer to the shore, the Seaside was renamed several times and gradually declined. It was razed in 1959 to enlarge the Myrtle Beach Pavilion Amusement Park. Both locations of the pioneer inn were within the amusement park district now awaiting redevelopment.

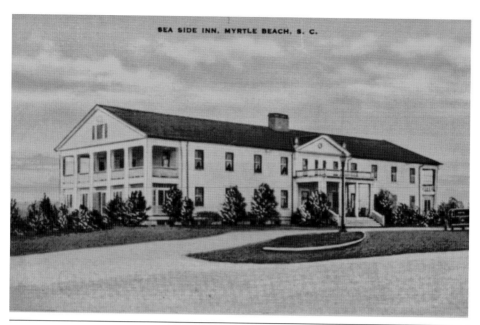

SEA SIDE INN, MYRTLE BEACH, S. C.

Lafayette Manor, briefly named the Sea Side Inn to retain the name of Myrtle Beach's pioneer hotel, was built on Ninth Avenue North in 1929 by Myrtle Beach Investment Company. Originally a private hotel, it soon opened to the public and eventually had 50 bedrooms. The hotel briefly housed the town's first Seacoast Telephone office in 1936, when service began with 25 telephones. Lumber, bricks, and other architectural elements salvaged from its 1960 demolition were reused to build several local homes. The land, called Lafayette Square, was absorbed by the Myrtle Beach Pavilion Amusement Park.

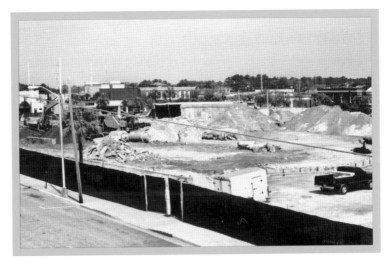

The original wooden Myrtle Lodge burned and was replaced with this brick hotel in 1939 at 406 Eighth Avenue North. It was owner-managed by Eliza Thompkins, who also owned Hotel Kelly around the corner at 706 North Kings Highway. Willie Mae Thompkins and Carolyn Garren were other lodge managers. The lodge was razed in 1969, and its land was incorporated into the Astro Needle Park and later into the Myrtle Beach Pavilion Amusement Park, now also razed.

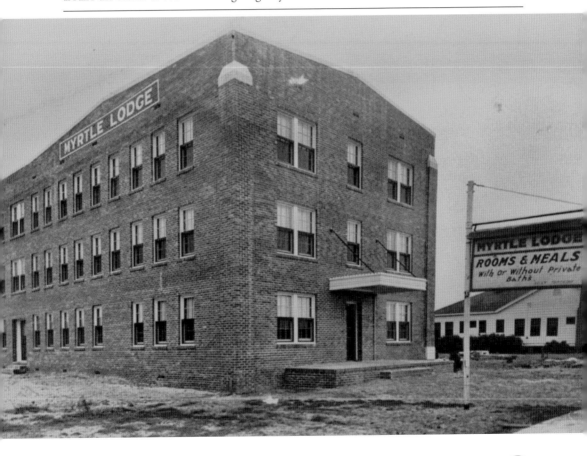

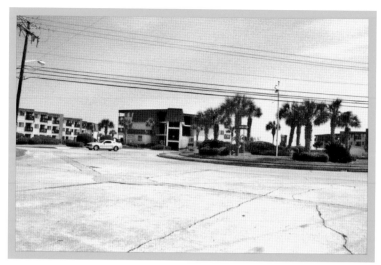

The Ocean Forest Hotel, 5601 North Ocean Boulevard, was completed in 1929 and opened the following February with an elaborate gala. The 10-story Georgian hotel was popular for conventions but changed ownership regularly over several decades while gradually declining. Needing costly renovations in 1974, it closed forever and was imploded. Ocean Forest Villas, a modular condominium resort with 157 units, occupies the 10-acre site of this former landmark still recalled as the area's grandest early hotel. These views show the back side of both properties.

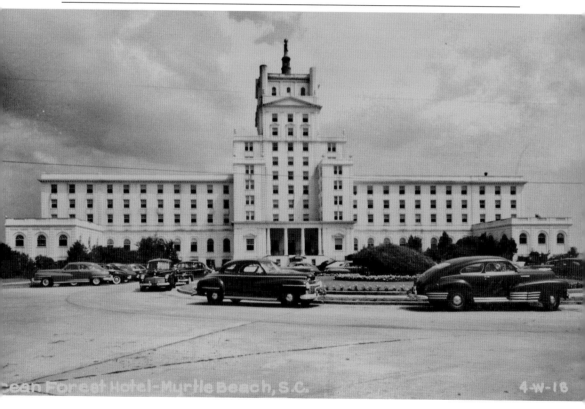

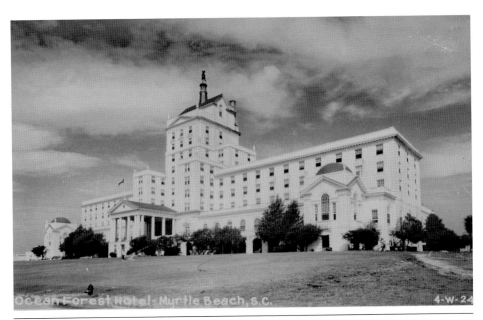

The Ocean Forest Hotel, seen from its ocean side, featured an Olympic-size indoor swimming pool filled with seawater. The curative powers of the ocean were also delivered to each hotel's bathroom, which had three bathing options—hot water, cold water, and seawater. Cagney's Old Place Restaurant on North Kings Highway is the largest known repository of Ocean Forest artifacts. The villa buildings were arranged on the property in a pattern that maintained some original hotel pathways.

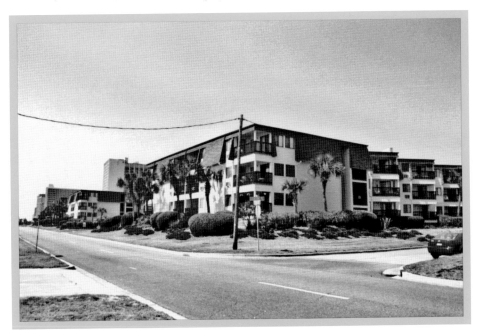

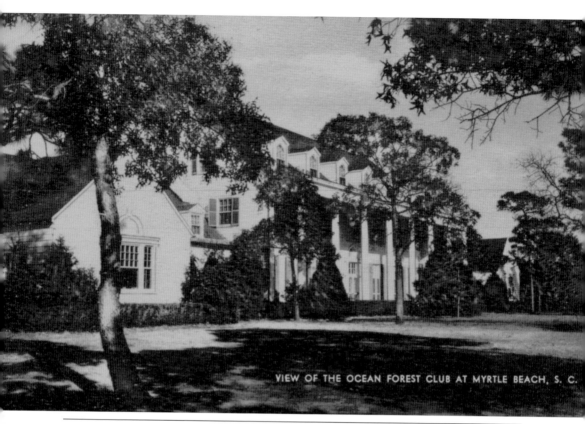

VIEW OF THE OCEAN FOREST CLUB AT MYRTLE BEACH, S. C.

The Ocean Forest Country Club and Inn, 5603 Woodside Avenue, opened in 1927 with 50 guest rooms. Renamed Pine Lakes International Country Club when purchased by Fred A. Miles in 1944, it no longer houses guests but remains a prestigious location for parties and other events. This National Register building is undergoing a renovation to accompany a reconfiguration of its golf course and an expansion of its residential neighborhood.

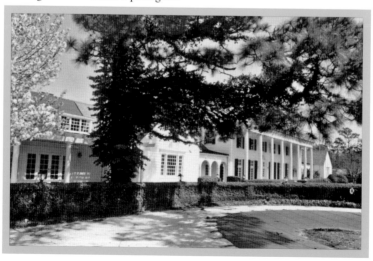

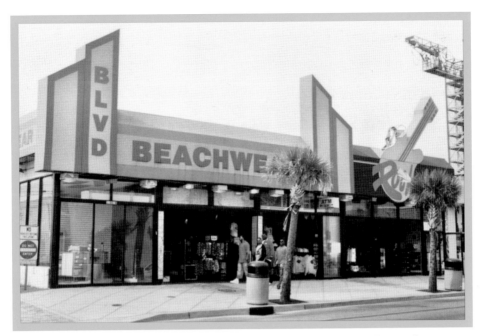

The Kentucky Inn, 1105 North Ocean Boulevard, was a 1940s guesthouse managed by Lena Harris and later by Neil W. Goodyear and Reba R. Goodyear. This second-row property situated between the Placid and the Carolina Inn was converted to commercial use as the amusement district impacted neighboring properties. It is now Boulevard Beachwear.

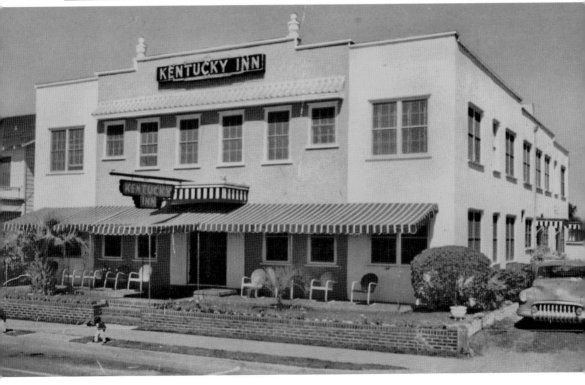

The Patricia Manor and Hotel, 2710 North Ocean Boulevard, is renamed the Patricia Grand Resort and was rebuilt as a condominium tower hotel with 308 units. The manor was started by Pat Ivey in the 1930s, and the hotel opened in 1942, by which time her husband, Joe C. Ivey, was listed as owner-manager. Gordon and Jean Beard managed it for many years, too.

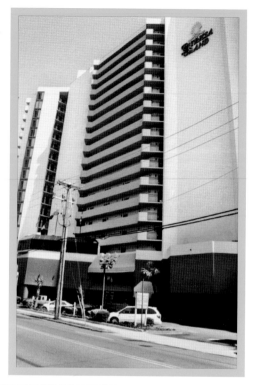

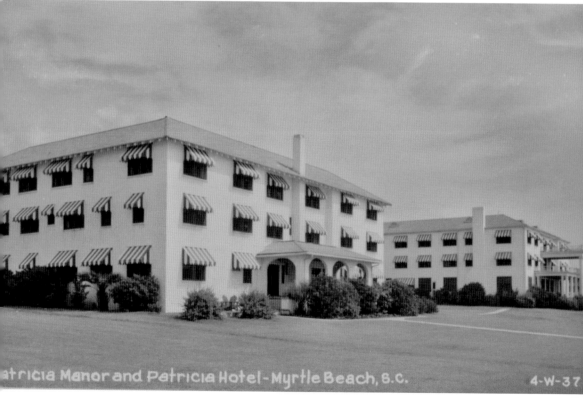

atricia Manor and Patricia Hotel-Myrtle Beach, S.C. 4-W-37

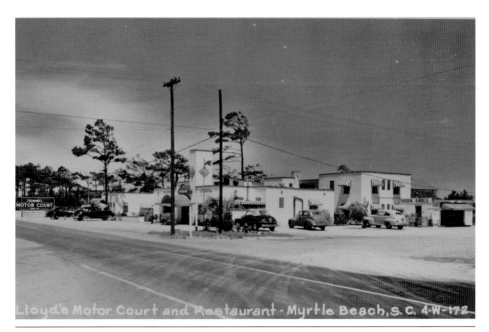

Lloyd's Motor Court and Restaurant, 1604 North Kings Highway, was owned by Henry Lloyd Macklen and was renowned for its restaurant's cuisine. Elliott's Motor Court was another name for this property opposite Chapin Park and now occupied by Wings, a beachwear store.

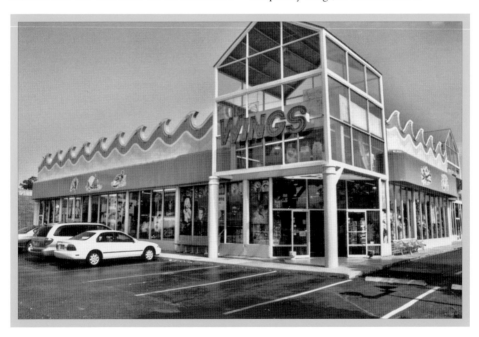

The Ocean Plaza Hotel and Fishing Pier, 1400 North Ocean Boulevard, was the former Myrtle Beach Yacht Club, built in 1922. It was owned by Mr. and Mrs. Keith Jones and managed by Archer Myers when this aerial view was taken in the 1960s. The Ocean Plaza was razed in the early 1970s and replaced with Myrtle Beach's first modern high-rise, the Yachtsman Inn.

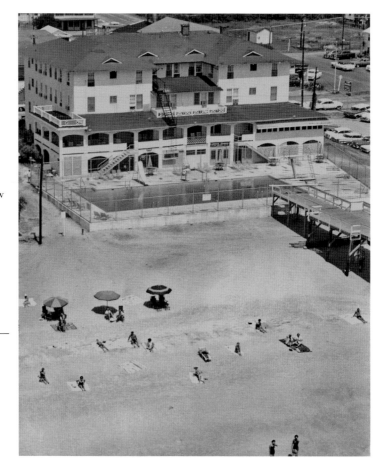

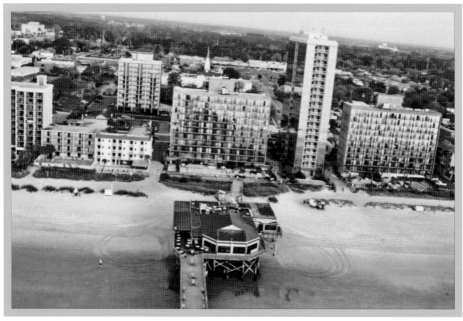

The Breakers, 2006–2008 North Ocean Boulevard, was built in 1927 as a beach house and was enlarged to become a hotel of 30 rooms managed in its early years by Mrs. T. S. Means and Mattie Mae Avant. Vernon Brake ran this hotel for 34 years before retiring in 2006. It is now the Breakers Resort with 546 units spread over three buildings, including a 20-story condominium tower.

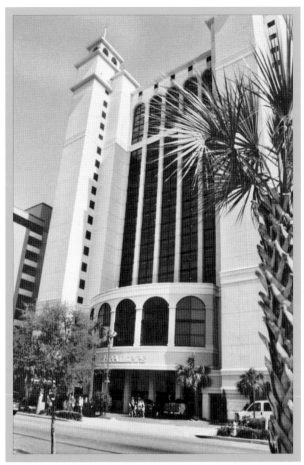

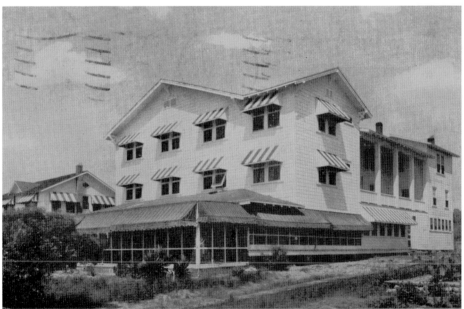

The Lucky Strike Hotel, 1101 North Ocean Boulevard, was a second-row guesthouse of the 1940s managed by Mrs. Stafford Smith (Bessie) and later by Mr. and Mrs. H.T. Hatchell. It was situated between the Blue Sea Inn and the Placid, now a corner site because of the extension of Eleventh Avenue North (renamed Joe White Avenue). By 1947, Myrtle Beach was booming with 11 hotels, 12 motor courts, and 161 guesthouses.

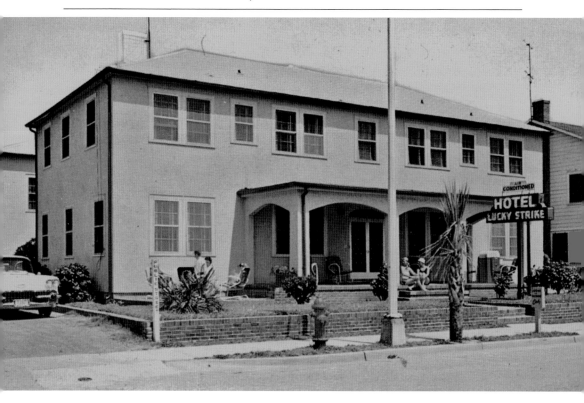

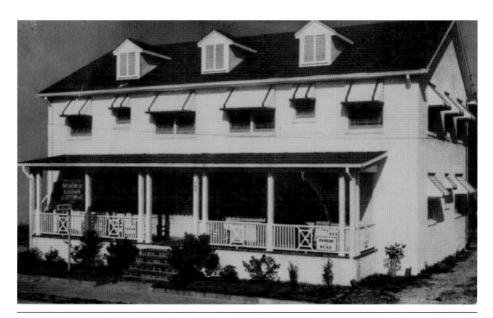

Beverly Cottage, 703 North Ocean Boulevard, belonged to Mrs. Grover Beverly. It was rebuilt as the Beverly Motel in a modern architectural style named Populuxe, which dominated post–World War II motel construction from 1945 to 1963.

Myrtle Beach once had over 40 Populuxe motels, most of which replaced smaller guesthouses destroyed by Hurricane Hazel in 1954. The Beverly had 43 units when it closed in 2006. It is shown vacant and for sale.

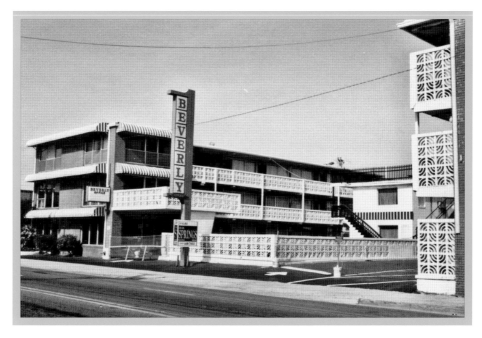

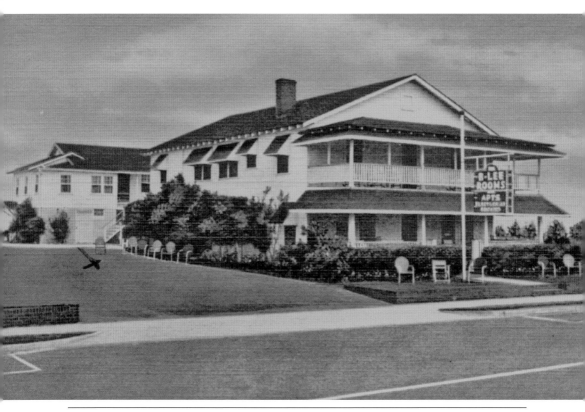

The B-Lee, 1603 North Ocean Boulevard, was a second-row guesthouse owned and operated by Mr. and Mrs. G. B. Cartrette in the middle of the 20th century. It was replaced by an expansion and reconstruction of the Florentine hotel next door after 1973. The aging Florentine was recently acquired by the Roxanne Towers hotel, located opposite it on the oceanfront.

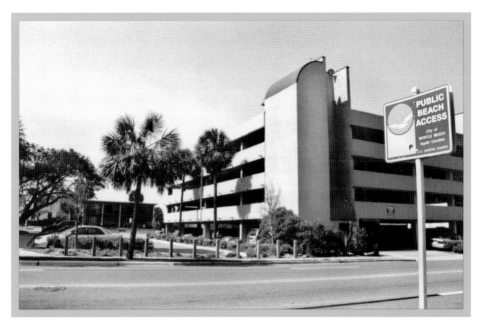

The Martha Fickling, 2311 North Ocean Boulevard, was a second-row guesthouse run by Martha Fickling in 1944 and still going strong three decades later. The site is now a parking lot beside a parking garage. Traditionally women ran most cottage hotels in early Myrtle Beach, serving as hostess, reservationist, bookkeeper, cook, maid, and whatever else was needed. Their dedication and success built local tourism, one visitor at a time.

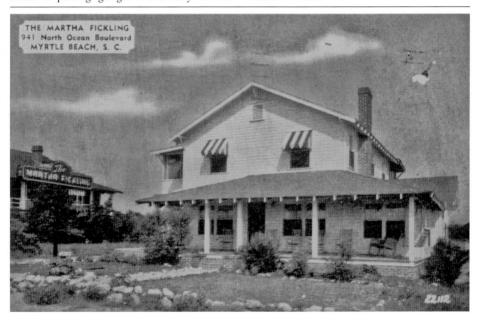

THE MARTHA FICKLING
941 North Ocean Boulevard
MYRTLE BEACH, S. C.

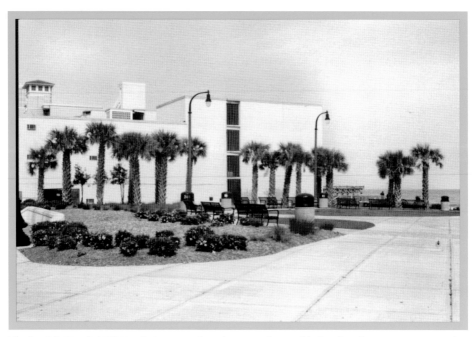

The Sea Side Hotel, 1000 North Ocean Boulevard, replaced a beach house adapted as a guesthouse, the Welcome Inn, owned by Mr. and Mrs. M. A. Gause. The Sea Side was known for its Do-Nut Dinette, serving Krispy Kreme doughnuts and a sandwiches. The Gauses named their hotel for Myrtle Beach's first hotel. Its site is now within the Justin W. Plyler Boardwalk Park, named for an entrepreneur who owned an amusement park, Gay Dolphin Park at 910 North Ocean Boulevard, later replacing it with Gay Dolphin Gift Cove.

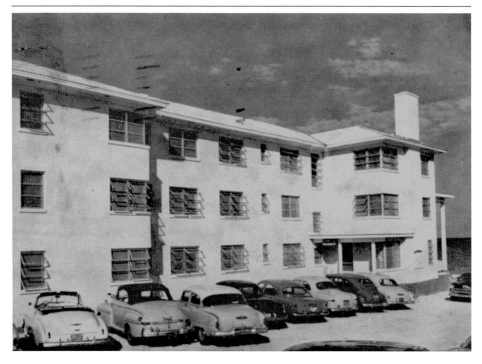

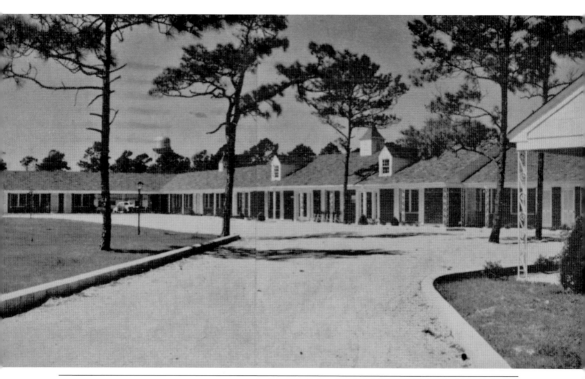

The Dogwood Motor Court was a 22-room motel at 3001 North Kings Highway. In 1953, it was owned and operated by John Hendley and J. B. Morris Jr. Later managers were Mr. and Mrs. W. O. McCarthy. This motor court had a television lounge. This site is now occupied by a shopping center strip named Kings Plaza, anchored by Surf City and Dunkin' Donuts.

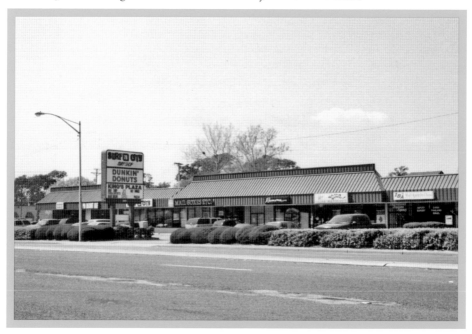

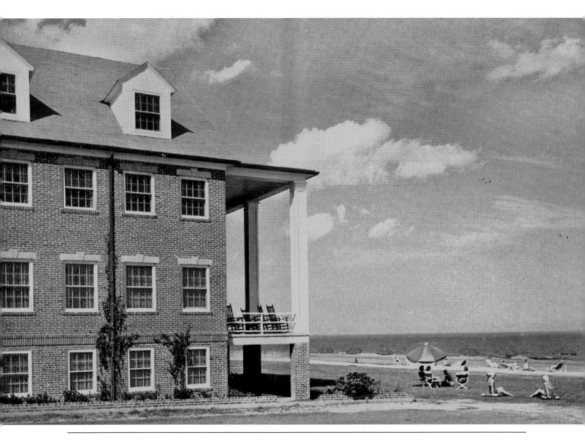

The Chesterfield Inn, 700 North Ocean Boulevard, began in 1936 in a five-bedroom house beside the lot on which its Colonial Revival structure was built in 1946. The inn was started by Steve C. Chapman from Chesterfield. Chapman's nephew, Clay Brittain, managed the inn, later purchasing it and continuing its operation for decades before selling it. The Chesterfield is a National Register property and the oldest oceanfront hotel in Myrtle Beach still operating in historic facilities.

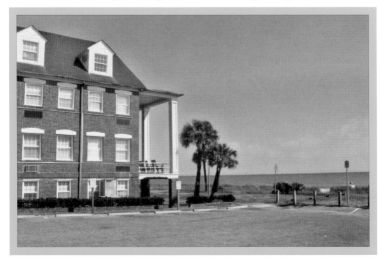

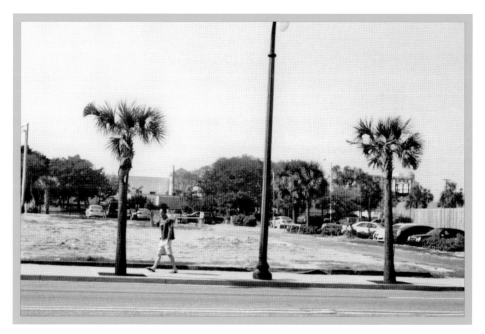

The Belvedere, 1903 North Ocean Boulevard, was a second-row guesthouse managed by Mrs. John D. Dixon and later by Vivian P. Marlow. Room rates in 1953 were $5–$6 per person daily for double occupancy and $4.50 off-season. It was earlier owned by Mr. and Mrs. Fred Hucks of Conway, who ran it as the Huckslin Inn from about 1927 to 1945. The site is now vacant.

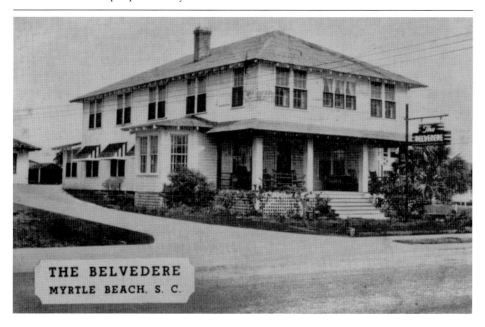

THE BELVEDERE
MYRTLE BEACH, S. C.

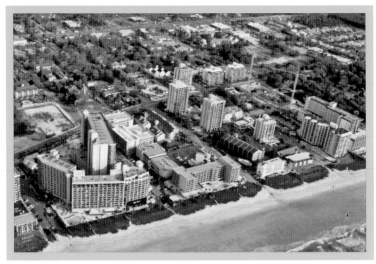

The Ocean Dunes Apartment Motel, 7400–7500 North Ocean Boulevard, had side-by-side twin buildings in 1964 when Bob McMillan managed it. Shown aerially in 2007, it later combined with the Sand Dunes Motel and is now the Sands Resorts, which can accommodate 4,000 guests in its six oceanfront properties, most of which are shown aerially here. The resort has 25,000 square feet of meeting space and is a leading convention facility in Myrtle Beach.

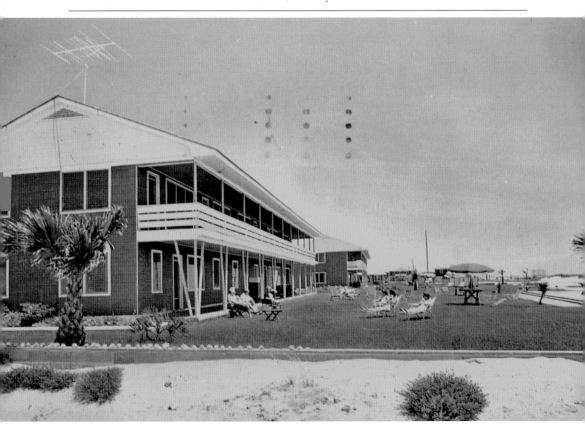

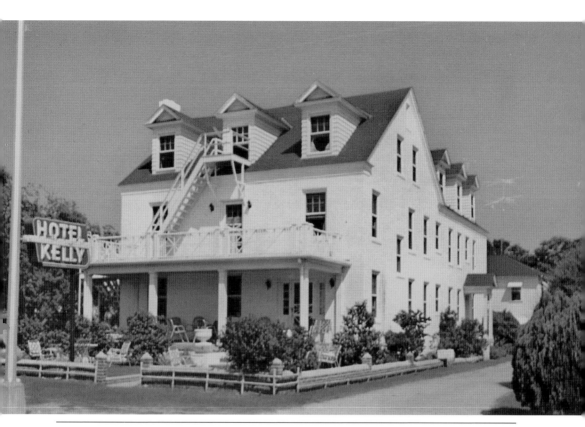

Hotel Kelly, 706 North Kings Highway, was a 20-room hotel belonging to Kelly and Eliza Thompkins and previously to his parents, Purley and Willie Mae Thompkins. Air-conditioning was optional, and the television was in the lobby, but the location was in the heart of Myrtle Beach. This was a second hotel property for Kelly Thompkins, who also owned and operated the nearby Myrtle Lodge.

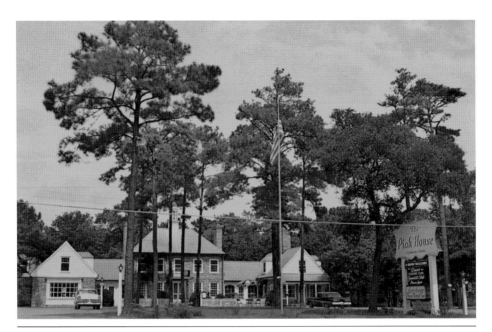

The Pink House, 4300 North Kings Highway, was built in 1945 with English bricks recycled primarily from abandoned Southern plantations. Built on a six-acre wooded tract, its six cottages surrounding a manor house were designed to resemble Colonial Williamsburg. Leroy H. Letts Sr. was the owner-manager. Holcombe Motor Lodge, White Heron Restaurant, and Christmas Elegance were other names for this property, which last operated as a Christmas shop. One cottage remains as the property awaits redevelopment.

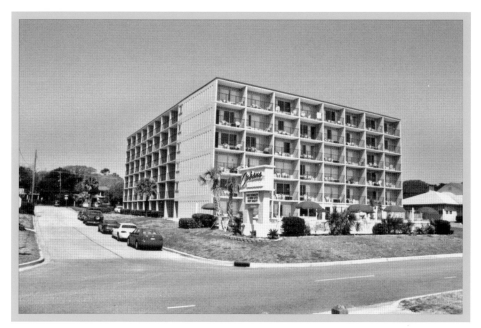

Gardenia Terrace Motor Hotel, 5701 North Ocean Boulevard, was Myrtle Beach's first oceanfront motel, built around 1948. Owned by Dr. James L. Martin of Mullins, it originally featured 20 units, later enlarged to 30 units, and served "home-cooked" meals in its restaurant. Mabel P. Burke was the manager of this motel located immediately north of the Ocean Forest Hotel. It was rebuilt at the Four Seasons motel and is renamed the Cabana Shores motel.

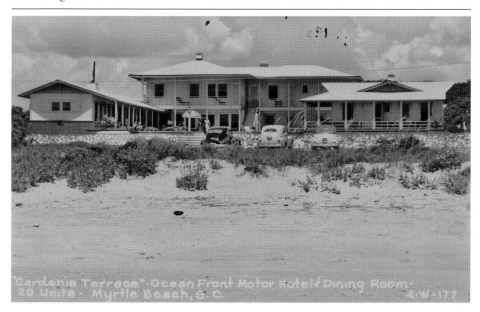

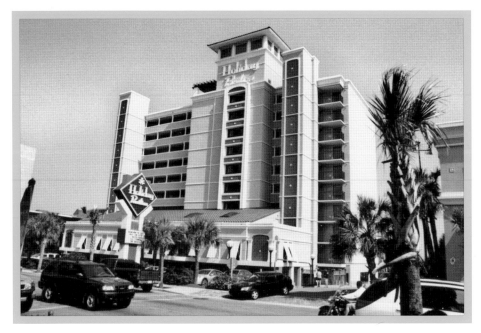

Holiday Inn, 1200 North Ocean Boulevard, belonged to Mr. and Mrs. George M. Hendrix. It had a popular rooftop sun deck but was not affiliated with the hotel chain by the same name. Recently rebuilt as a tower hotel, it has a new name, the Holiday Pavilion, and offers guests five swimming pools.

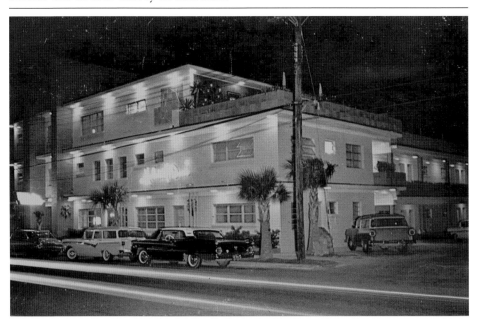

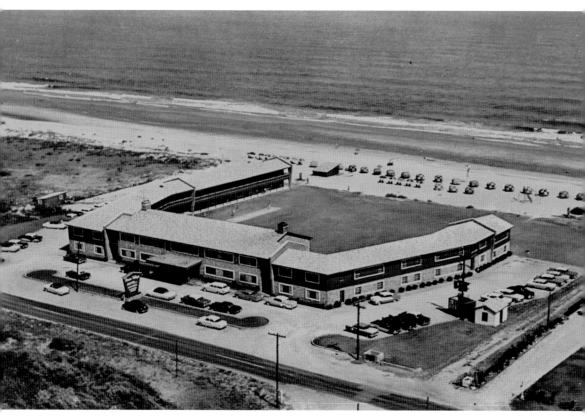

The Dunes Village Motel and Apartments, 5200 North Ocean Boulevard, opened in 1954. It was first owned by Joe Ivey and operated by Gordon Beard. Originally each unit had a sitting room, but the television was in the motel lobby. A swimming pool was soon added to the courtyard. Renamed the Dunes Village Resort, this property began with 77 units and had 93 units when it was demolished and rebuilt as a condominium tower hotel featuring an elaborate indoor water park.

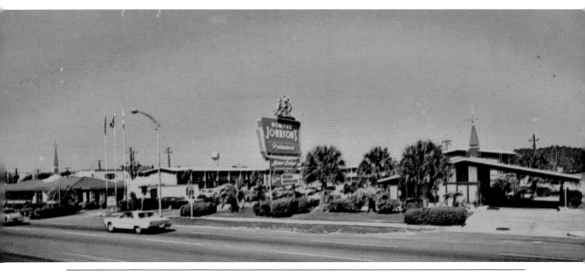

Howard Johnson's Motor Lodge and Restaurant, 1201 North Kings Highway, was the first chain motel to locate in Myrtle Beach. It opened about 1958 with a restaurant famous for its many ice cream flavors. James B. Little was general manager of the property. Mr. and Mrs. David Pierce later managed "Ho-Jo's." Renamed the Kings Road Inn when Howard Johnson's closed, this motel was recently demolished. Its restaurant survives as Beijing China Buffet.

BEACH ACCOMMODATIONS

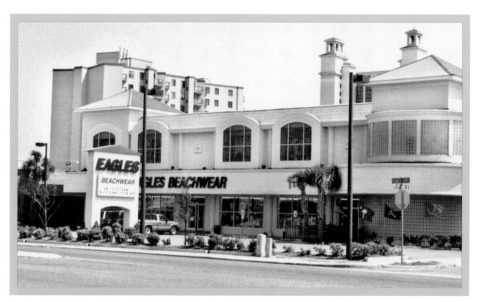

Monticello Motor Lodge, 1900 North Kings Highway, opened in 1953 with 16 rooms, some of which were air-conditioned. It first belonged to Mr. and Mrs. Peter Fields and was managed by Peter C. Maffey. Maude and Dan W. Allen Jr. later managed it. The building became a restaurant and later a store, Sunshine Camera, with a remodeled facade resembling a huge camera where people entered through its super-sized lens. Eagles Beachwear now occupies the site.

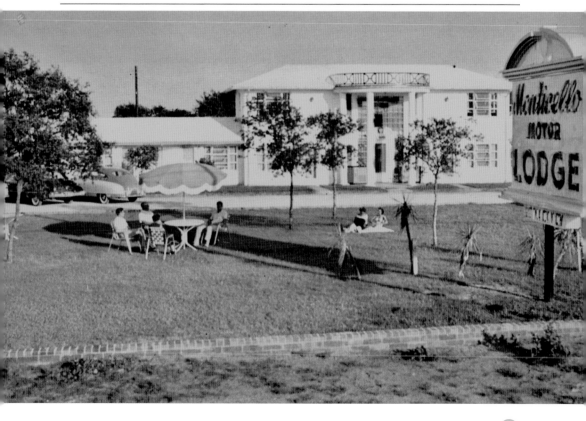

The Caravelle Hotel, 6900 North Ocean Boulevard, opened about 1960 and was managed by Mr. and Mrs. Joe Thompson. It has 574 units following a recent $8 million reconstruction of its main property, the Caravelle Tower. Its Santa Maria Restaurant is known for its excellent food.

Other properties the Caravelle manages are the Carolina Dunes, Sea Mark Tower, St. John's Inn, Arbor Condominiums, Caravelle Resort Hotel, Dry Dock Condominiums, Harborside Condominiums, and St. Clements.

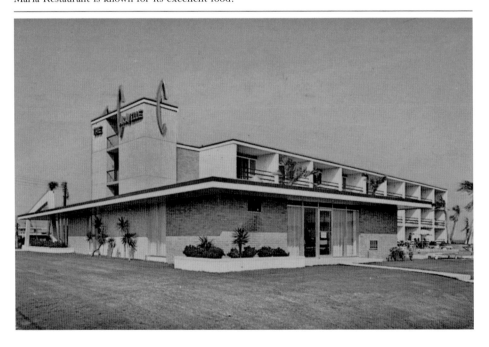

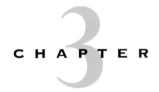
THE GRAND STRAND

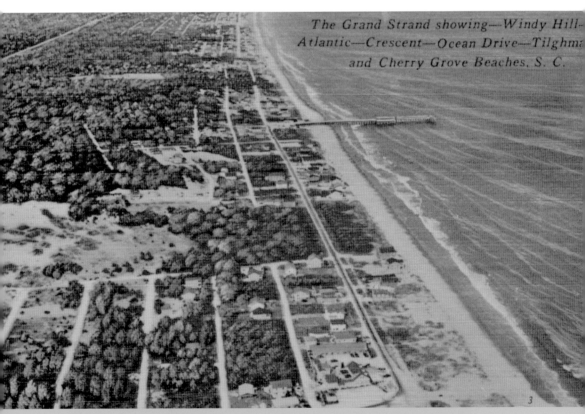

*The Grand Strand showing—Windy Hill—
Atlantic—Crescent—Ocean Drive—Tilghma
and Cherry Grove Beaches, S. C.*

The beaches of North Myrtle Beach were sparsely populated when this northern view was taken about 1949. Its population now exceeds 13,000. The city occupies nine miles of coast, excluding Atlantic Beach. It was incorporated in 1968 by consolidating Cherry Grove, Ocean Drive, Windy Hill, and Crescent Beaches.

Little River's deep-sea fishing fleet followed the timber industry as the primary source of its economy. This oldest community in Horry County is now primarily a port for large casino cruise vessels and a popular retirement community with an area population of 8,000. It remains an unincorporated village on Highway 17 near the North Carolina state line. Pirate activity here centuries ago suggests forgotten treasures may be buried beneath this coastal seaport.

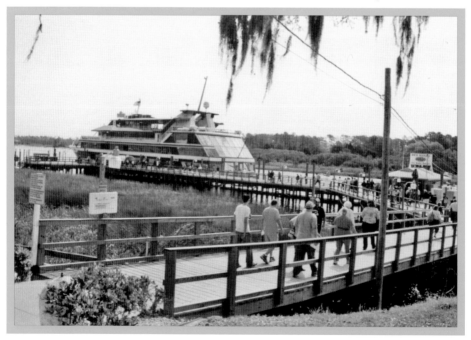

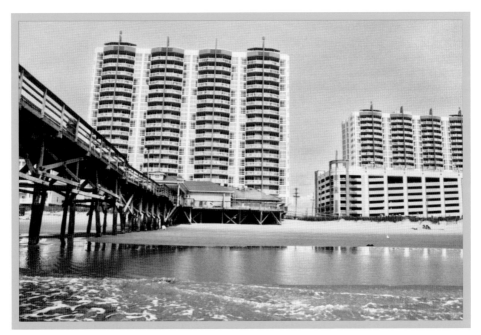

Cherry Grove Fishing Pier, 3500 North Ocean Boulevard in North Myrtle Beach, was built in the 1950s and is 985 feet long. It is pictured about 1960 and now includes a restaurant. A world-record tiger shark at 1,780 pounds was caught here in 1964. Property adjoining the pier is being redeveloped as Prince Resort, featuring twin, 18-story condominium towers. Other Grand Strand piers are Apache Pier, Pier 14, Second Avenue Pier, Springmaid Pier, Myrtle Beach State Park Pier, Surfside Pier, and the Pier at Garden City.

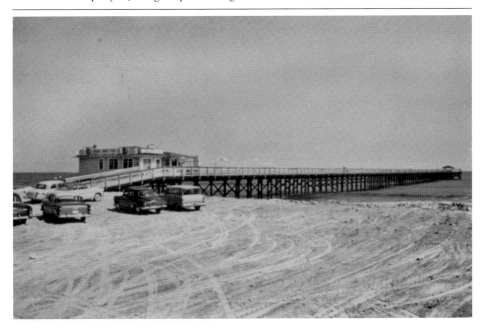

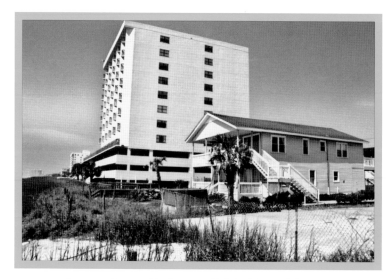

Ardlussa was an oceanfront guesthouse a block or two north of downtown Cherry Grove Beach. The unusual name of this house managed by Mrs. J. H. Rivers was derived from a Scottish estate. Built in 1930 by Daniel Hatcher Watkins, it was once called the House of Slamming Doors. It is believed to have been destroyed by Hurricane Hazel in 1954 and replaced with a house named the Sea Castle, also now absent from its neighborhood, pictured here.

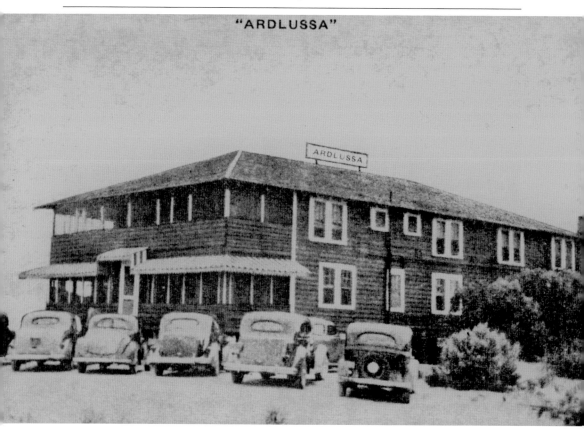

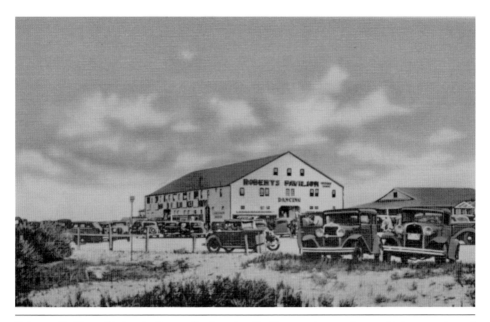

Roberts Pavilion, 91 South Ocean Boulevard in North Myrtle Beach, was a *c.* 1930s wooden pavilion destroyed by Hurricane Hazel in 1954 and replaced with Ocean Drive Pavilion, destroyed in 1989 by Hurricane Hugo. A third building, O. D. Pavilion, continues to host multiple generations of youths and adults who come for a dancing good time. Sunset Grill No. 2, Wheel Fun Rentals, and an ice cream café adjoining the pavilion.

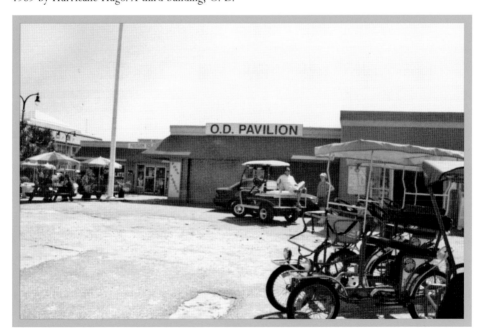

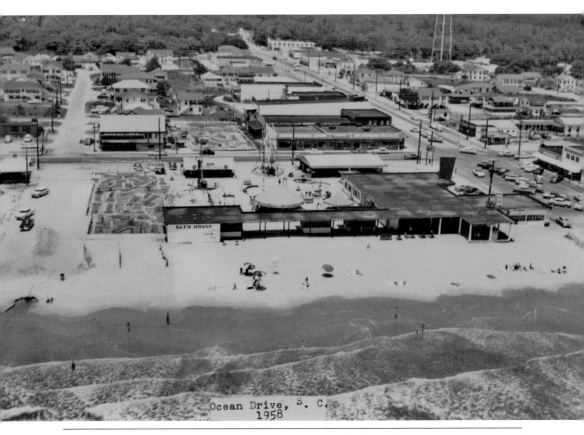

Ocean Drive, S. C.
1958

An aerial view of the Ocean Drive Pavilion in 1958 reveals the place claiming the origination of shag dancing. Pavilions in Myrtle Beach and Pawleys Island make similar claims, and all three pavilions likely influenced the popular dance's steps. Nightclubs in this vicinity host semiannual Society of Stranders (S.O.S.) Reunions of its 12,000 members, organized in 1980 to promote shag dancing.

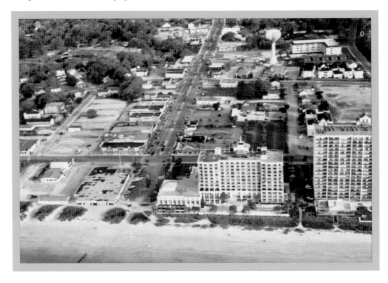

THE GRAND STRAND

Ocean Drive Amusement Center, 93 South Ocean Boulevard in North Myrtle Beach, closely resembled the traveling carnivals that are seen at state and county agricultural fairs. This oceanfront park adjoined the pavilion where rhythm and blues music in the 1930s led to the phenomenal popularity of Carolina beach music and shag dancing. It was replaced by Boulevard Grill.

A 1958 aerial view of Main Street in Ocean Drive Beach reveals the small town rebuilt after Hurricane Hazel wreaked havoc on October 15, 1954. Hazel was a category-four storm with winds of 145 miles per hour. It destroyed 450 houses in Ocean Drive and 273 houses in Myrtle Beach, including 80 percent of the oceanfront properties—mostly guesthouses.

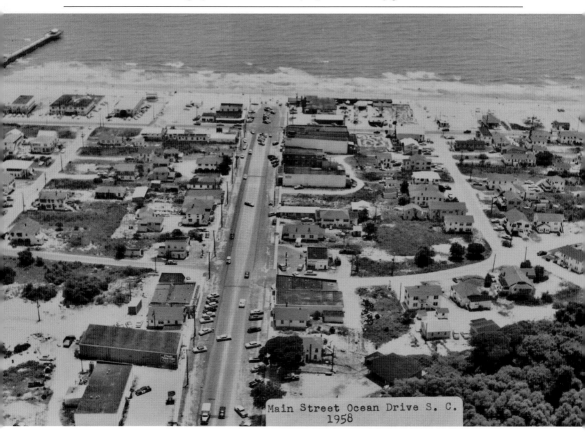

Main Street Ocean Drive S. C.
1958

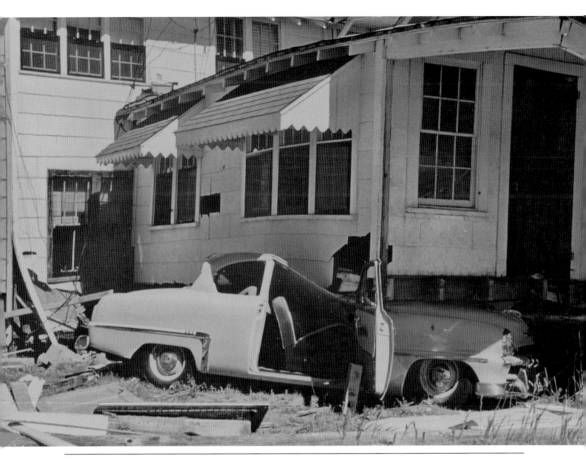

A car in the Ocean Drive section of North Myrtle Beach following Hurricane Hazel bears the weight of the house that crushed it during the storm's tidal surge. Order was gradually restored in the battered town, thanks to National Guardsmen who spent months removing and burning storm debris. Only a few vintage beach houses predating Hurricane Hazel remain in the Ocean Drive section of North Myrtle Beach; pictured is a survivor on First Avenue South.

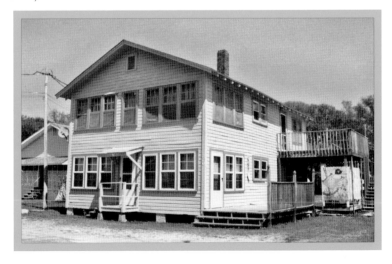

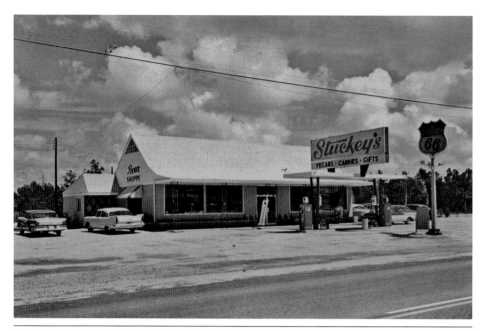

Stuckey's Pecan Shoppe, 1339 Highway 17 South in North Myrtle Beach, was a tourist souvenir stop in Crescent Beach. As the name implies, pecans were its specialty. Pecan log rolls made from nougat "logs" rolled in pecans were the store's best seller. Gasoline, citrus fruit, inexpensive souvenirs, and flavored pecans were other popular items. Bank of America now occupies the site.

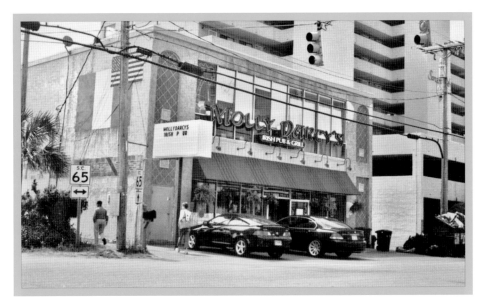

Crescent Beach Amusement Center was an oceanfront park at 1701–1709 South Ocean Boulevard in North Myrtle Beach. The rides weren't quite as spectacular as those in Ocean Drive Amusement Center and not nearly as spectacular as rides in Myrtle Beach, but they were mighty convenient for Crescent Beach vacationers. The park was the highlight of this beach's downtown and has been replaced with Molly Darcy's on the Beach, a pub and grill, and San-A-Bel Resort, a condominium hotel.

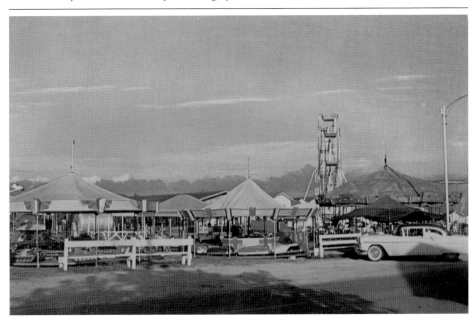

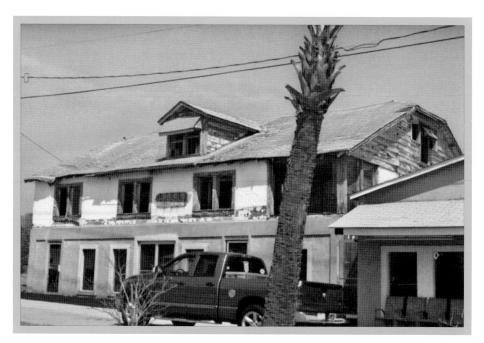

Hotel Gordon was on the oceanfront in Atlantic Beach, an African American resort nestled between the Crescent Beach and Windy Hill sections of North Myrtle Beach. It was built around 1940 and was razed in 2006, and the lot remains vacant. A 2007 view shows the Hotel Gordon's competitor, Hotel Marshall, which belonged to Robert Marshall and is closed. Nicknamed "The Black Pearl," this incorporated town of 400 residents encompasses four oceanfront blocks extending to Highway 17.

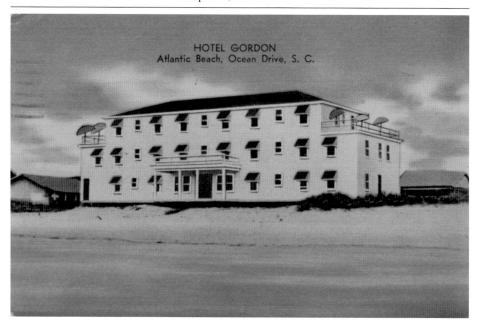

THE GRAND STRAND

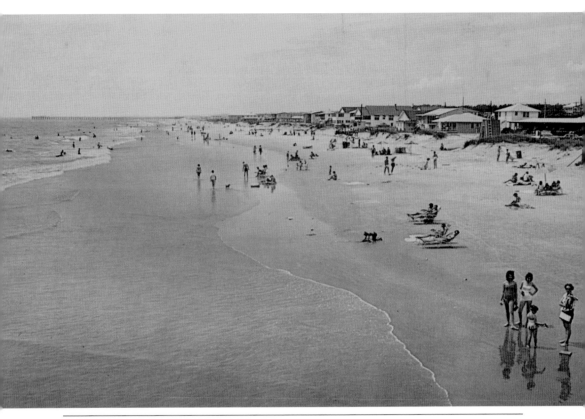

Aerial strand views in the Windy Hill section of North Myrtle Beach around 1960 and in 2007 illustrate its dramatic conversion from beach houses to towering hotels. This area has also seen the redevelopment of Sherwood Forest Campground as Ocean Creek Resort and Ponderosa Campground as Beach Cove Resort. North Beach Plantation is a twin-tower resort and residential housing complex under construction on 60 acres that was formerly Barefoot Campground immediately south of Windy Hill.

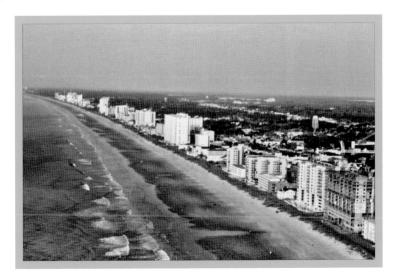

Barefoot Landing, 4898 Highway 17 South in North Myrtle Beach, began as the Village of the Barefoot Traders. Its original footprint featured 15 shops in a park setting beside Lake Louie, created as an enlargement of White Point Swash, first named Gause's Swash for William Gause's 1737 grant of 250 acres. The landing boasts over 100 businesses offering shopping, dining, and entertainment located on both sides of the scenic lake and bordering the Intracoastal Waterway.

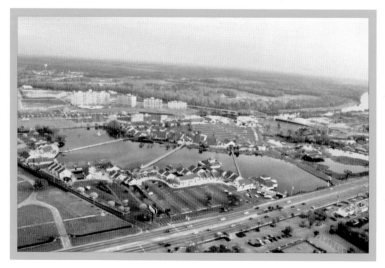

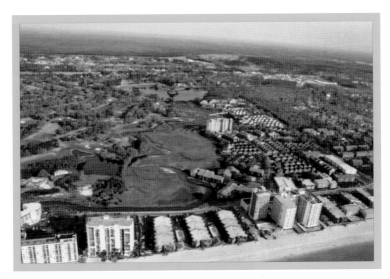

Enormous natural sand dunes once dominated the north end of Myrtle Beach just above the Dunes Golf and Beach Club and Singleton Swash. Shown about 1929, the dunes' size can be compared with the man and car on the left below them. The same area shown aerially in 2007 has minimal dunes that are undetectable in this view. Sands Beach Club and Brigadune Condominiums are two oceanfront resorts shown here on Shore Drive.

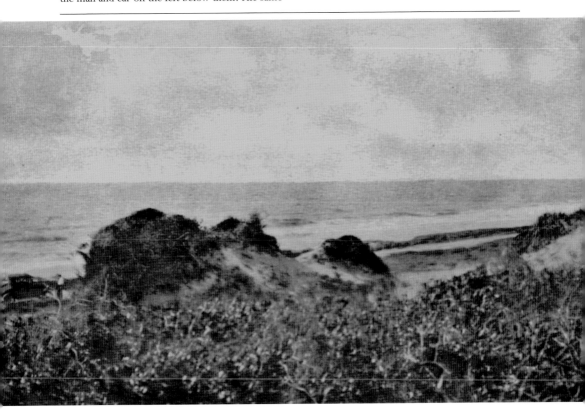

Surfside Beach Fishing Pier, 11 South Ocean Boulevard in Surfside Beach, was 750 feet long when constructed in 1953. It is shown about 1960 and aerially in 2007. The pier was a focal point in the development of this family-oriented beach formerly known as Floral Beach. Days Inn Surfside Beach Resort is associated with the pier, which includes Nibils Restaurant and Surfside Pier Trading Post. Surfside incorporated in 1964 and has about 5,000 residents.

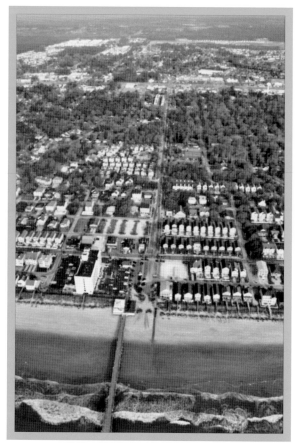

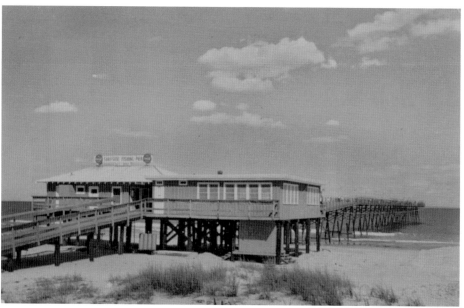

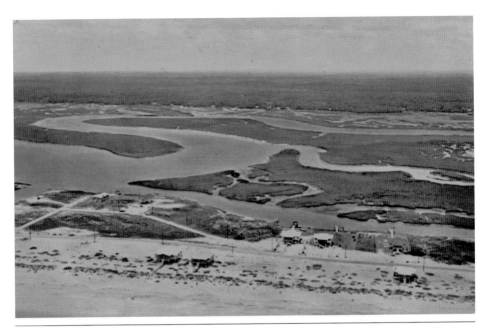

A bird's-eye view of Garden City Beach and Murrells Inlet in the 1960s shows a sparsely populated beach in sharp contrast to its present status. Murrells Inlet claims to be the seafood capital of South Carolina with over 30 seafood restaurants. Its 2,000-foot marsh walk has a new Veteran's Pier, replacing an earlier one used during World War II by U.S. Coast Guard crash boats. The population of unincorporated Murrells Inlet is 6,000.

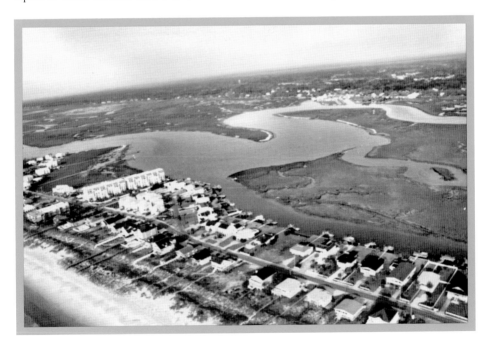

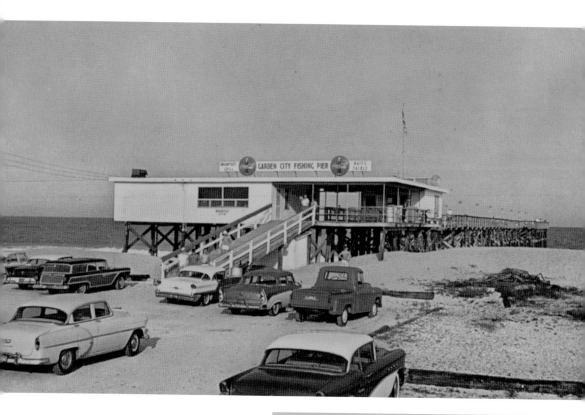

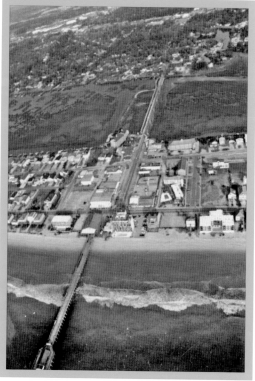

A vintage view of Garden City Fishing
Pier, 110 Waccamaw Drive in Garden
City Beach, reveals its parking area
before adjacent construction necessitated
parking under the pier's building. The pier
and nearby development are also shown
aerially in 2007. Garden City Beach is
unincorporated and divided by the Horry
and Georgetown County line. It has a
community association that works for local
improvements and sponsors family events.
The area population is about 10,000.

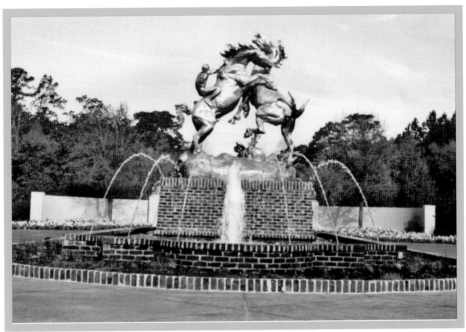

Fighting Stallions is an oversized aluminum statue created by Anna Hyatt Huntington for Brookgreen Gardens' entrance on the Ocean Highway, three miles south of Murrells Inlet. Huntington and her husband, Archer, purchased four adjoining, defunct rice plantations and created a sculpture garden they opened in 1931. It showcases hundreds of sculptures by world-renowned artists, most of which are exhibited in outdoor garden settings.

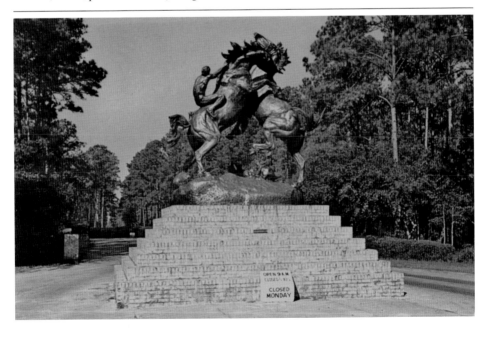

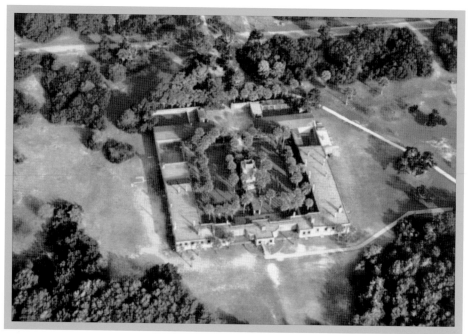

Huntington Beach State Park, 16148 Ocean Highway in Murrells Inlet, is seen about 1960 across its dunes, providing a surf view. This 2,500-acre state park is leased from Brookgreen Gardens and was part of the Huntingtons' 1930 purchase of 9,000 acres on the Waccamaw Neck. Its focal point is the Huntingtons' Moorish summer residence, Atalaya Castle, an oceanfront National Register property built in the early 1930s. The castle is shown aerially in 2007, and its park is considered an excellent birding site.

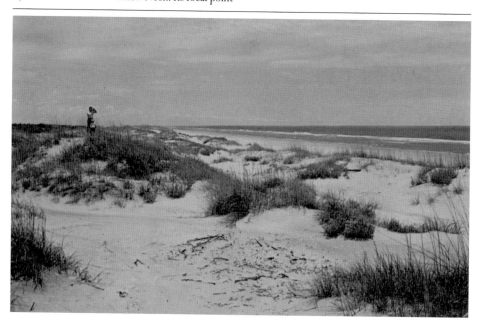

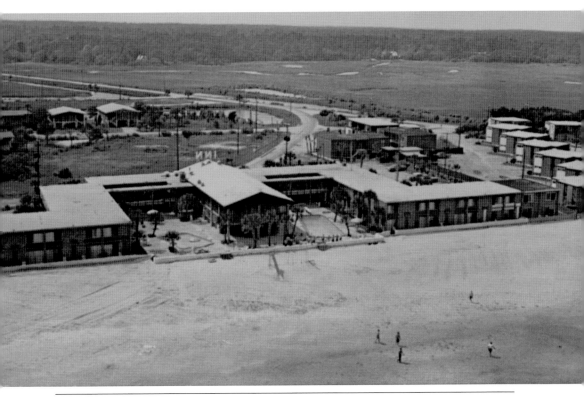

The oceanfront Litchfield Inn, 1 Norris Drive in South Litchfield Beach, began the upscale development in 1959 of the former Magnolia Beach, originally part of Litchfield Plantation's ocean-to-river land holdings. It is the only oceanfront hotel in Georgetown County and can be accessed by crossing Clubhouse Creek on Litchfield Boulevard. The population of unincorporated Litchfield Beach is nearly 4,000.

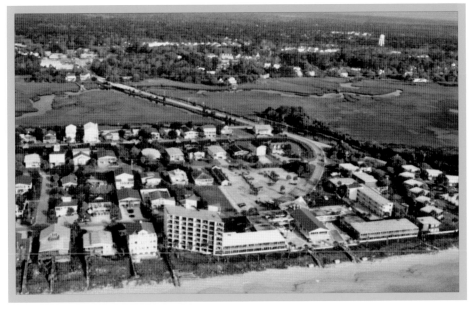

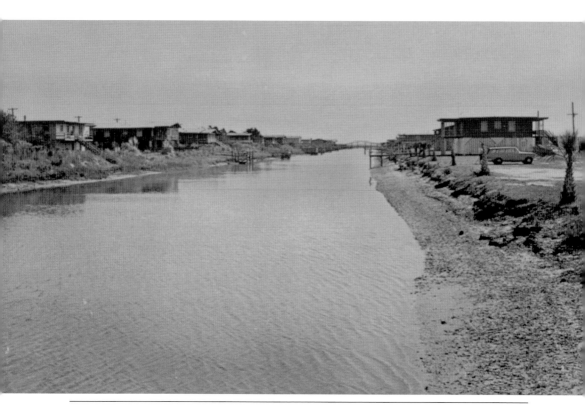

Channels were carved from salt marsh to create waterfront lots during the development of South Litchfield Beach around 1960, prior to regulations prohibiting the altering of natural wetlands. Named Sportsman Canal and shown new and in 2007, this channel provides landowners private boat docking for easy access to water sports. The beach is situated about midway between Myrtle Beach and Georgetown.

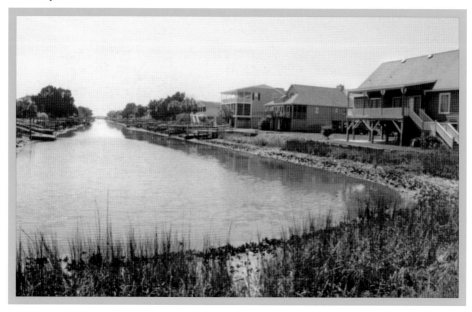

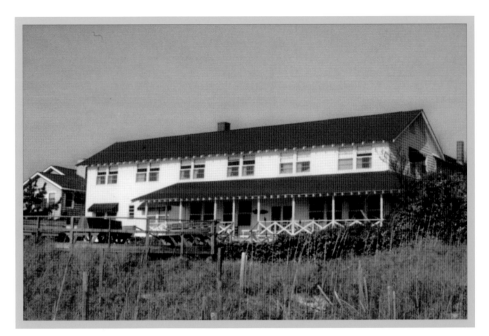

The Sea View Inn, 414 Myrtle Avenue in Pawleys Island, has preserved a yesteryear atmosphere into the 21st century with 20 guest rooms and dining-room meal service. Shown in 1937, when Mrs. W. H. Clinkscale ran her new inn while living next door, and in 2007, the Sea View continues serving old-time Southern hospitality with a side order of Southern cooking.

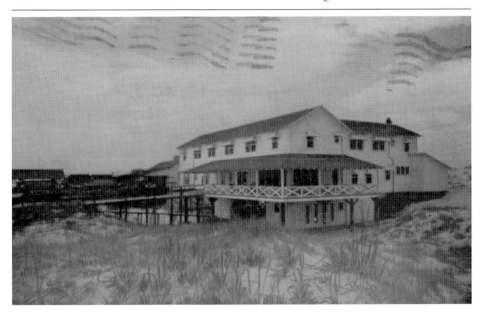

All Saints' Parish, Waccamaw Episcopal Church is at 3560 Kings River Road on mainland Pawleys Island, previously called Waverly Mills. The parish dates to 1767, and the church's antebellum membership of rice planters included some of America's wealthiest families. Pictured in 1936 and in 2007, the church now holds services in the newest sanctuary on its campus.

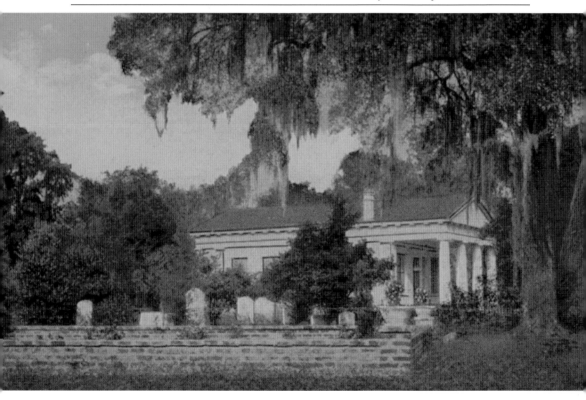

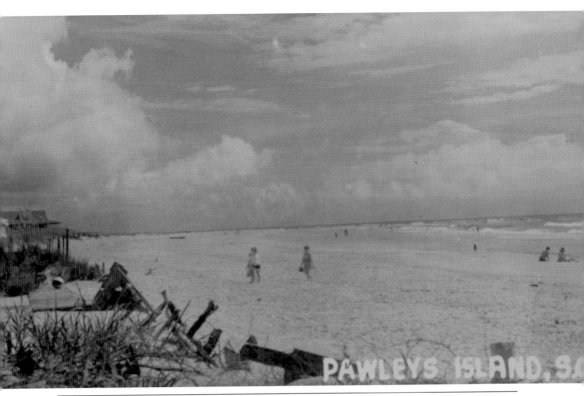

Pawleys Island claims to be amongst the oldest seaside resorts in America. Surviving 19th-century houses, several exhibiting 18th-century construction details, are interspersed with newer ones along its four-mile ribbon of land. Groins projecting from the beach into the ocean attempt to curb erosion on this island renowned for a relaxed atmosphere and rope hammocks. The island population is about 200, but its mainland population is much larger.

THE GRAND STRAND

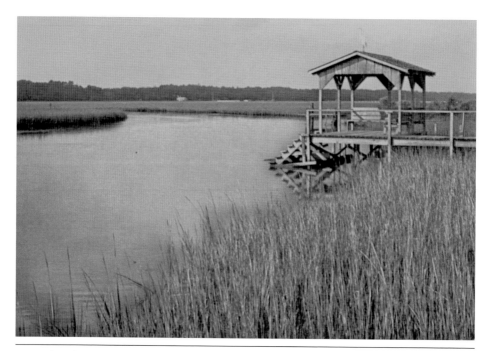

A weathered dock shelter overlooks Pawleys Island's marshy inlet in a timeless view from the 1970s. Wind-sculpted trees seen in 2007 shade one of eight historical markers erected to preserve the lineage of island houses that front the beach yet also view the marsh. This marker describes Liberty Lodge at 520 Myrtle Avenue. A Pawleys Pavilion Reunion brings thousands to this idyllic island annually for a summer evening of beach music and shag dancing, reminiscent of when Pawleys had a dance pavilion built over this marsh.

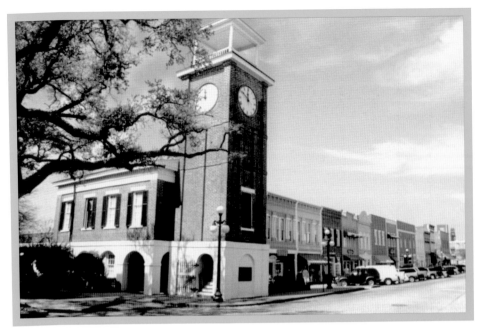

The Grand Strand extends to Georgetown, symbolized by its historic town hall, now the Rice Museum at 637 Front Street. Devoted to telling the story of the county's wealthy antebellum rice culture, the clock tower building has also been a jail, a newspaper office, an open-air market (before its ground floor was enclosed), and a chamber of commerce. It is a National Register building dating to 1842 and is shown here in the late 1930s and in 2007.

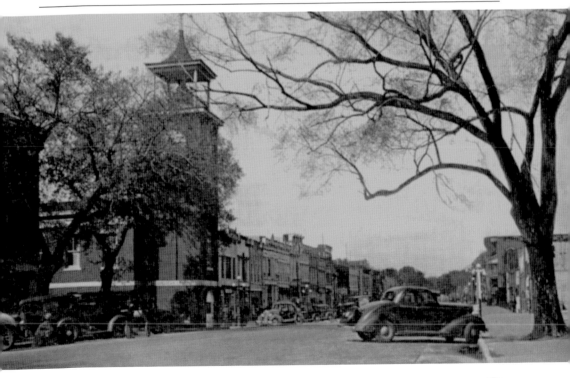

DISCOVER THOUSANDS OF LOCAL HISTORY BOOKS FEATURING MILLIONS OF VINTAGE IMAGES

Arcadia Publishing, the leading local history publisher in the United States, is committed to making history accessible and meaningful through publishing books that celebrate and preserve the heritage of America's people and places.

Find more books like this at
www.arcadiapublishing.com

Search for your hometown history, your old stomping grounds, and even your favorite sports team.